New Hampshire
DINERS

· ·

CLASSIC GRANITE STATE EATERIES

Larry Cultrera

AMERICAN PALATE

Published by American Palate
A Division of The History Press
Charleston, SC 29403
www.historypress.net

First published 2014

Manufactured in the United States

ISBN 978.1.62619.401.4

Library of Congress CIP data applied for.

Contents

Foreword

In Larry Cultrera's past life he was a diner. (Take your pick; I'd say he might have been a diner similar to Casey's in Natick, Massachusetts). In his present life, he's a leading authority in the world of dinerdom with his power-packed, eventful and fully loaded blog, www.dinerhotline.com. In his future life, Larry's legacy will endure as a notorious diner archaeologist, historian and general-purposes storyteller in the tradition of Mark Twain. If he were a counterman, he'd be presented with a James Beard award, several times over.

Larry's passion for diners and their history has no boundaries. His limitless, thirty-four-plus-year fascination with diner history has given him a reputation of bringing warm delight to anyone who's in his presence or who is lucky enough to share a meal with him at a favorite diner of his—even not a favorite. And he'll tell you why it isn't. He's perfectly at ease with all the ins and outs of any diner, any period and any owners he knows well and not at all. His encyclopedic journeys are wonders to behold, full of color and flavor. The reader will soon join in on another adventure, chock-full of tales, visual delights and, above all, a symbiotic closeness rare in the annals of all the folks who share similar affection in the diner culture community.

<div align="right">

JOHN BAEDER
Nashville, Tennessee
May 2014

</div>

Acknowledgements

T hanks as always to my wife, Denise, for putting up with me all these years. I know it has not been easy for her, having to live with this "diner obsession." Thanks also to my colleague and friend Richard J.S. Gutman, the foremost authority on diner history, for all his help and encouragement throughout the last thirty-plus years. Dick also was kind enough to read through the manuscript as well as provide some photos included in this book. It was his initial and exhaustive research back in the early 1970s that created the basis of knowledge that helped fuel the interest people like me have for this subject. I cannot forget Steve Repucci, my longtime friend and road-trip companion, who helped to steer this fascination into a full-blown obsession. Another longtime friend and road-trip companion whom I met on the diner trail is David Hebb. I want to thank David for his contribution of the "before" photo of the Mt. Pisgah Diner when it was still at its first location in Gardner, Massachusetts. Special thanks to my good friend and kindred spirit John Baeder whose book *Diners*, filled with his wonderful paintings and sketches, was a total inspiration to me and how I approach documenting diners with my own photos. I am grateful for his taking the time to write the foreword for this book. I also want to give a shout-out to my friends and fellow History Press authors Michael Gabriele and Garrison Leykam for all their encouragement, as well as including me in their respective books *The History of Diners in New Jersey* and *Classic Diners of Connecticut*.

Other people who have assisted me with information and who have been longtime colleagues are Colin Strayer, Randy Garbin, Steve Harwin, Gary

Thomas and Michael Engle. Thanks also to Jonathan Yonan for the last-minute replacement interior photo of Gilley's P.M. Lunch. In addition, there were quite a few diner owners and former owners as well as other people who have been extremely helpful during my research for this book. Among these people, I am extremely grateful to Debbie Burnham, library technician at the Laconia Public Library; Sharon M. Jensen, DPW executive secretary for the Town of Derry; Dave Pierce, the popcorn stand manager for Goffstown Lions Club; and David Palance and Polly Cote, president and historian, respectively, at the Milford Historical Society. I am extremely grateful to Mike Barrett, Mary Caron and the current owners John and Nick Grimanis for information on the Hillsborough Diner. Thanks also to the Grimanis family for allowing Gilman Shattuck, curator of the Manahan-Phelps-McCulloch Photographic Collection at the Hillsborough Historical Society, and Beatrice Jillette to create a digital reproduction from the rather large framed photo of Zeke's Diner to be used in this edition. Thanks, Gil and Bea!

Thanks to Roger Rist of George's Diner (a very congenial host for sure); Will Scopa of the Silver Lake Railroad; Chris and Patti Williford of the Littleton Diner; Holly Burnham, Leann Briggs and Steve Shorey of the Four Aces Diner; Alex Ray of the Common Man family of restaurants; Roger Elkus and Daryl McGann of Roger's Redliner Diner; Carol Lawrence of the Red Arrow Diners; Karen Lewis, manager at Mary Ann's Diner (Derry); Bruce Balch and Loucas Tserkezis of the Sunny Day Diner; Cindy Spain as well as Jerry and Tina Nialetz of the Bristol Diner; Debbie Carter of Daddypop's Tumble Inn Diner; Rose Pucci, Bonnie Noyes and Katherine Blackey Clark of the Union Diner; and Dori Dearborn of Main Street Station Diner for their help providing information on their respective diners. Thanks also to Kenneth Osgood Jr. (Spider Osgood's son) and Gary Anderson of New Hampshire Movies Inc. for insights on Spider Osgood, the legendary short-order cook. I also want to thank Katie Orlando and the crew at The History Press for all their help and guidance throughout this project. Finally, thanks to all the New Hampshire diner owners not named here who took time out of their schedules to speak with me, however briefly, during the course of their busy days. I salute all of you and only wish you a prosperous future in all your endeavors, serving good food and congeniality to appreciative customers like me.

Introduction

New Hampshire Diners: Classic Granite State Eateries will appeal to history buffs, diner aficionados and "foodies," as well as the casual road-tripper. This book will introduce the reader to some of the classic diners currently operating in the Granite State as well as be a brief primer of the history of this uniquely American institution. The history of diners in New Hampshire is similar to that of the other New England states. Diners began, basically, with the introduction of horse-drawn lunch wagons that were initially produced in Worcester, Massachusetts, from the late 1870s into the early 1900s. The companies that produced these wagons were started by men such as Samuel Messer Jones, Charles Palmer and Thomas H. Buckley and were eventually superseded by companies such as the Worcester Lunch Car Company of Worcester and J.B. Judkins Company of Merrimac, Massachusetts, among smaller local concerns. Enterprising men who saw the appeal of operating their own businesses bought these lunch wagons and provided food to customers who were out and about, usually at night after other brick-and-mortar food establishments had closed for the day. Some of the food in the earlier wagons was premade while the later wagons had minimal cooking facilities to provide the patron with hot dogs, hamburgers, various other sandwiches and coffee. Many of these wagons were strategically located in downtown business areas, either near the town common or other high-traffic areas adjacent to mills, factories, theaters and other entertainment or civic venues. As time went on and the industry changed, the larger diners started supplanting the more mobile lunch wagons coming into the Granite State.

They were usually located along the main roads between towns and cities as well as in busy downtown areas. By the 1950s, the manufacturing center for diners had already migrated from New England into the Mid-Atlantic states of New York and New Jersey, where there were many more companies that built diners. Inevitably products from some of those companies made it into northern New England as well, joining the many New England–built diners already in the state (and, in some cases, replacing older diners).

I originally hoped to arrange the chapters in this book similar to my previous book (*Classic Diners of Massachusetts*). In that first book, I was able to separate the chapters into groupings of diners based on geographic location. But the location of diners in New Hampshire at best can be described as being in small clusters that are fairly spread out, which ultimately made the geographical groupings not workable for this edition. Another factor in deciding how to arrange the chapters was that New Hampshire is fairly unique among all the other states in the region of northern New England. Mainly because, over the last thirty or so years, some diners have been moved out of state or demolished while quite a few have been relocated to New Hampshire from other locations out of state.

Therefore, Chapter 1 covers early New Hampshire diner history and contains postcard images of lunch wagons as well as a surviving example of a truck-pulled diner and a popcorn wagon that was once pulled by a Model T Ford. Chapter 2 highlights longtime favorite diners, and Chapter 3 features transplanted diners. Chapter 4 covers on-site and homemade diners while Chapter 5 explores New Hampshire diners now living a new life in another state, and finally, Chapter 6 reviews diners that no longer exist.

For the novice, I will start your education by giving you my definition of a classic diner: a custom-built (prefabricated) building, assembled in one or more sections and delivered to a predetermined operating location. Diners historically have been constructed by a handful of manufacturers primarily located in the northeastern United States. In some cases, I will note that more than a few diners listed here are actually built on site (rather than factory built). I will make exceptions for these, as they represent, by their layout, ambience and menu served, a great example of a true diner-like experience that should not be ignored. I also want to say that I purposely did not try to list many (if any) menu items for any particular diner in this edition because most of the diners actually feature similar menus. Also because of space limitations, the information on the menus would not fit, and it would have seemed redundant. Suffice to say that all the diners featured in this book serve great food at reasonable prices and, with a few exceptions, feature fairly large menus.

Brief History and Timeline

In this day and age, there are still people who believe that all diners are converted trolley or train cars. While I cannot argue that, over the years, there were some diners converted from streetcars and railroad rolling stock, this was the exception rather than the rule; in fact, there was at least one known example that I can cite located in New Hampshire: the Ella May Diner of Lincoln (now demolished) was a converted trolley car. More than likely, there were others through the early years of the twentieth century, but none are known to currently exist. Knowledge of their locations may be lost to posterity.

Diners actually have their own unique history that started here in New England in 1872, primarily in Providence, Rhode Island, with the birth of Walter Scott's Lunch Wagon. Shortly thereafter, they were taken to a whole new level in Worcester, Massachusetts, where the first companies started manufacturing lunch wagons (and then diners) from the late 1800s to the early 1900s. Most of New Hampshire's diners can be dated from the 1920s to the 1950s and were primarily built by Massachusetts firms like Worcester Lunch Car, J.B. Judkins Co. (Sterling diners) of Merrimac and Pollard and Co. out of Lowell. There are quite a few New Jersey–built diners, which date mostly from the 1950s, represented here as well. Part of the reason that few newer diners exist in northern New England is the demise of the local builder, the Worcester Lunch Car Company. Worcester built and delivered its last diner, Lloyd's Diner of Johnston, Rhode Island, in 1957, and the assets of the company were auctioned off

in 1961. Ironically, Lloyd's Diner is currently operating as the Route 104 Diner in New Hampton, New Hampshire. As history has shown with the advent of split-construction (another term is modular construction), the Mid-Atlantic diner manufacturers were continually building bigger and better diners—or, as they were beginning to be called, diner-restaurants. The price of shipping these diners was starting to be restrictive, and only one 1960s-vintage diner was delivered into the Granite State: Lindy's Diner of Keene, built by Paramount Diners. The newest diner to come into the state was not delivered until early November 2001. It is located in Rochester and was operated by at least two different operators as the Remember When Diner. Built by Starlite Diners of Florida, this place has had a rough time of it, and although it still looks like it always has (on the exterior), it has closed as a regular diner and is currently being operated as a Mexican restaurant.

There are many built-on-site diners sprinkled throughout the Granite State, longtime favorite places like George's Diner in Meredith and the Red Arrow Diner of Manchester. There are also newer places that have developed a huge following like Mary Ann's Diner of Derry and Joey's Diner of Amherst. While New Hampshire has lost its fair share of diners since I started documenting them, the state has actually gained at least one brand-new diner and quite a few used diners as well. In fact, New Hampshire stands apart from all the other New England states primarily because it has received a rather large influx of transplanted diners in the last thirty-four years. There are three diners operated by Alex Ray that come under the umbrella of his Common Man family of restaurants: the aforementioned Route 104 Diner, the Tilt'n Diner of Tilton and the Airport Diner of Manchester. Both the Tilt'n and Route 104 Diners are part of that phenomenon of transplanted diners while the Airport is a built-on-site example.

The following is a historic timeline of the evolution from lunch wagon to diner to large, multisectioned restaurants. This information is based on the work originally researched and compiled by my colleague and friend Richard J.S. Gutman, who wrote the definitive history of diners in the book *American Diner Then and Now* (Harper Collins, 1993, and reprinted by Johns Hopkins University Press, 2000).

PROVIDENCE, RHODE ISLAND, 1872

Walter Scott introduced the first night lunch wagon, a converted freight wagon with windows cut into the sides. Due to the fact that most restaurants closed after 8:00 p.m., Scott saw a ready-made clientele of night-shift workers and other people out and about in the late evening and into the overnight hours. He handed out previously prepared sandwiches, pie and coffee to those late-night customers who thronged to his wagon. Within a short time, Scott developed a fleet of these night lunches, and other businessmen saw the success that Scott was having and opened their own wagons. A standout among Scott's emulators was Ruel B. Jones, a Providence police patrolman, who became very successful running a fleet of seven wagons.

WORCESTER, MASSACHUSETTS, 1884

Samuel Messer Jones, a cousin of Ruel Jones, moved to Worcester from Providence and introduced the first lunch wagon to this city. Sam Jones became successful enough to afford to have a new wagon built in 1887, which was large enough to house a small kitchen and also to accommodate a handful of customers, who for the first time could actually come inside to order and eat their food. This feature was especially welcome on nights when the weather was inclement. In 1889, Jones sold all but one of his fleet of wagons to Charles H. Palmer.

WORCESTER, MASSACHUSETTS, 1891

Charles Palmer received the first patent given for a lunch wagon design. This patent described what was to become the standard configuration for the next fifteen to twenty years or so.

WORCESTER, MASSACHUSETTS, 1892

Thomas H. Buckley started the New England Lunch Wagon Company, which later evolved into the T.H. Buckley Lunch Wagon and Catering Company. This company not only built lunch wagons but also sold equipment to be used in them. Buckley, who was described as the first "lunch wagon king," was credited with setting up wagons in some 275 towns across the country and was the originator of the White House Cafés, the most upscale and famous of the mass-produced lunch wagons of late 1890s.

WORCESTER, MASSACHUSETTS, 1905

Wilfred H. Barriere, a carpenter who formerly worked for Buckley, went into business with blacksmith Stearns A. Haynes to form a new company constructing lunch wagons. This was taken over by Philip H. Duprey and renamed the Worcester Lunch Car and Carriage Manufacturing Company in 1906.

NEW ROCHELLE, NEW YORK, 1905

Patrick J. Tierney began manufacturing lunch wagons and is credited with introducing many improvements to the lunch car during his tenure (1905–17).

BAYONNE, NEW JERSEY, 1913

Jerry O'Mahony began manufacturing lunch cars with partner John J. Hanf. O'Mahony was destined to become the leading manufacturer of lunch wagons and diners for decades. The three previously mentioned manufacturers were the early pioneers in this industry, and many companies were to come after them. Many of these newer concerns were started from former employees of Tierney and O'Mahony, including most notably DeRaffele, Kullman and Fodero.

HALEDON, NEW JERSEY, 1941

Paramount Diners patented the split construction method that became widely used by most companies thereafter. This enabled the manufacturers to build diners in multiple sections for transportation to operating locations. This method of modular construction continues to this day with a handful of companies still building what most people call diners.

1
Lunch Wagons in New Hampshire

From the first appearance of the horse-drawn lunch wagons in the late nineteenth century through the turn of the twentieth century, it seemed they could be found anywhere in the New Hampshire. Although maybe not in huge numbers as seen in southern New England, there certainly were quite a few showing up usually in places like in-town business districts as well as recreational areas in cities and towns throughout the Granite State. Even as the predecessors to the modern diners, lunch wagons were a little different stylistically than their later counterparts. Factory-built lunch wagons varied in size but were generally eight feet wide by eighteen feet in length. They had two high rear wheels with two smaller front wheels for steering. The kitchen compartment was across the rear separated by a serving counter from the "eating area." There were usually stools around the interior perimeter with a narrow shelf-type counter under the windowsills. As in other large cities, these roving lunch wagons may have started interfering with traffic from other horse-drawn vehicles as well as trolley cars and automobiles. This certainly became a factor as they continued in popularity into the 1910s, mostly in cities like Manchester and Concord as opposed to the more rural areas of the state. Citing traffic and curfew laws, the larger cities especially started to curtail the hours of operation of these lunch wagons to the overnight hours. This action severely limited the amount of money the lunch wagon proprietors could make. In the thirty-four or so years that I have collected diner memorabilia and ephemera, I have managed to gather a decent amount of old postcards. This collection includes not only examples that

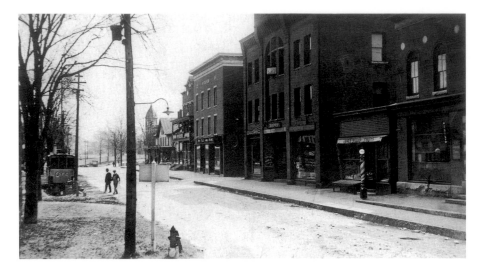

A postcard showing an early lunch wagon (left) plying its trade on the north side of Central Street in the Woodsville section of Haverhill, New Hampshire. The date of January 20, 1914, is clearly marked on the front, showing a scene that was commonplace in the late 1800s and early 1900s. Although the lunch cart is long gone, most of the buildings on the far side of the street still exist today. *Collection of the author.*

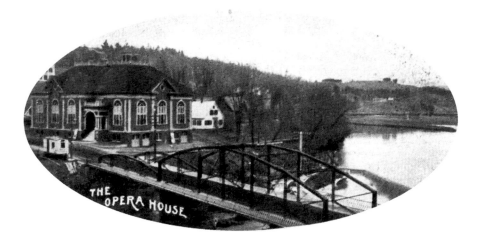

An even earlier postcard dated 1905 showing a lunch wagon situated across School Street from the Opera House in Lisbon, New Hampshire, hard by the bridge over the Ammonoosuc River. This looks to be an economy model, not as fancy as some wagons of the period. *Collection of the author.*

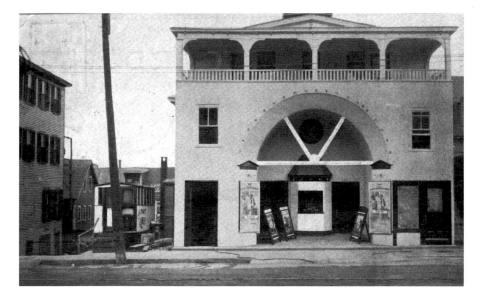

Some of these enterprising lunch wagon operators saw that they could circumvent the traffic laws in the larger cities by setting their wagon onto a sliver of land off the street and continue to operate at all hours. This image from a postcard with a 1916 postmark is a great example of a lunch wagon putting down semipermanent roots. This wagon is more than likely providing food service for the townsfolk as well as the patrons of the Broadway Theater in downtown Derry, New Hampshire. *Collection of the author.*

advertised individual diners but also street scenes that included diners and, more importantly, lunch wagons within the streetscape. The images on this page and page 18 are examples from my collection.

Eventually, the lunch wagon manufacturers saw that the need for transporting these early lunch wagons nightly was starting to change, so they took the opportunity to start building them longer and wider. This new, larger configuration added more seating and kitchen space to the wagons. Also at this point in time, eating in a railroad dining car was considered the height of luxury, and the longer lunch wagons were being designed with a strong resemblance to their railroad counterparts. So by the mid-1920s, the term "lunch wagon" was supplanted by the term "dining car" or to the shortened version—"diner." From this point on, diners started to become full-service restaurants serving breakfast, lunch and dinner. The following two examples in this chapter are of the last surviving old-time lunch wagon and what I like to call its second cousin—a home-built popcorn wagon—still operating in New Hampshire.

GILLEY'S P.M. LUNCH, 175 FLEET STREET, PORTSMOUTH, NEW HAMPSHIRE

1939 Worcester Lunch Car

Still in operation today, Gilley's P.M. Lunch (aka Gilley's Diner) in Portsmouth represents the final remnant of old-time lunch wagons in the Granite State. According to a photocopied handout I received back in the 1980s, there was an early horse-drawn lunch wagon operated circa 1910 by a guy named Ed Rowe, who eventually sold the business to Clarence Allan, who purchased a larger lunch wagon. This also was a horse-drawn lunch affair, which was built by Albert Closson of Glen Falls, New York, circa 1912. (It should be noted that Closson lunch wagons were extremely rare in New England.) In 1912, Frank Leary and William Kennedy purchased the business from Mr. Allan, who replaced the horses with a tractor (truck) in 1923. The current Worcester Lunch Car replaced this wagon in 1941.

As stated in the list of manufacturers (Appendix IV at the end of this book), Worcester Lunch Car and Carriage Manufacturing Company (aka Worcester Lunch Car Company) started out building horse-drawn lunch wagons in 1906. These were generally small units that could hold a handful of patrons as well as serve customers through takeout windows on either side of the cart. As time went on, the wagons got bigger, and the configuration of the interior changed to conform to what we now are more familiar with: the classic long counter with stools and, eventually, table and booth service. Although the diners they built got larger over the years, Worcester still offered small units, including a number of lunch wagons. These newer lunch wagons were either built on the back of a truck like the 1918 vintage Conlin's Lunch Wagon of Providence, Rhode Island (WLC No. 310), and the 1947 vintage Hickey's Diner (WLC No. 798) of Taunton, Massachusetts, or pulled behind a truck such as the 1933 vintage Behan's Diner (WLC No. 719), also of Taunton.

Also, lunch wagon/diner king Al McDermott (Al Mac) of Fall River, Massachusetts (in business since 1910), had a couple of mobile lunch wagons built by Worcester in the late 1930s to early 1940s. The first—WLC No. 744, built in 1939—was pulled by a truck and was called the White House Café. Al Mac's other lunch wagon from this period, the Nite Owl—WLC No. 786—was built in 1945 and was truck-mounted. This one stayed in Fall River until the mid-1950s, when it was superseded by a small nonmobile, stainless steel–covered diner. The old Nite Owl disappeared at

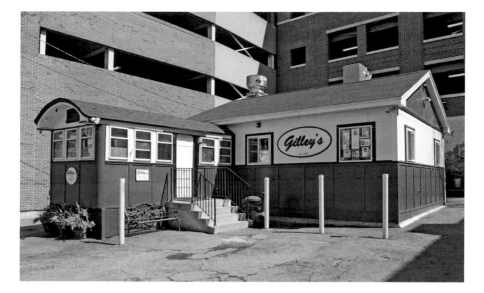

Gilley's P.M. Lunch is a rare survivor that has changed with the times. Although the truck that pulled it is gone and the diner is no longer mobile, it was recently altered with a large addition to conform to current code requirements. Interestingly, the lunch wagon remains 85 percent original. *Photo by Larry Cultrera.*

this point. The White House Café operated in Fall River until 1941, when it was sold to William Kennedy to replace his older Closson lunch wagon in Portsmouth.

There is a mural behind Gilley's painted by John Perry that depicts the original Closson wagon in Market Square. The used Worcester-built wagon continued to operate for many years as Kennedy's P.M. Lunch Cart, and the portable diner was still pulled into the Market Square area nightly. The lunch wagon stayed in the Kennedy family and was operated by his twin daughters, Joan Kennedy and June Murray. By June 1974, Gilley's (as it was known by then) was owned primarily by June and her husband, John. It also stopped being moved daily and planted roots near the public parking lot on Fleet Street. Gilley's is named after longtime employee Ralph "Gilley" Gilbert. Gilley served dogs and burgers from the diner's tiny kitchen for over five decades. An icon in Portsmouth history, Gilley was known for his flawless memory, kindness and generosity. He greeted his customers by name, had a good word for everyone and never let a lack of funds prevent a hungry customer from eating. Gilley died in 1986, but his name and fame continue today.

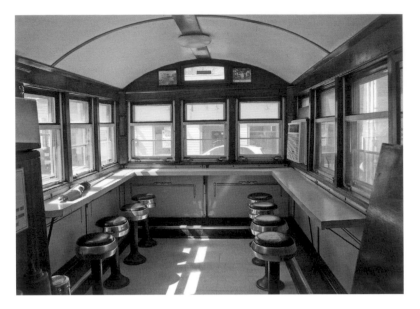

Here is the view from behind the serving counter at Gilley's. Visible in this shot are the stools and window shelves where a handful of patrons can still enjoy their food. *Photo by Larry Cultrera.*

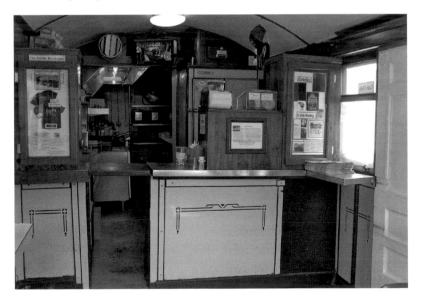

Looking at the serving counter and former kitchen area at Gilley's. With the large addition, the kitchen and storage area has been increased. To gain access to the new section, the changes to the lunch wagon were minimal, keeping as much of the original design and layout without sacrificing workability. *Photo courtesy of Jonathan Yonan.*

Although permanently situated, Gilley's retains almost all its same characteristics and authenticity as when it was mobile. The truck that towed the diner was still attached to the front of the structure until recently, and the wheels remain under the current structure. The interior contains the original oak trim and barrel ceiling along with the porcelain-enameled steel wall panels and fixtures. Many details have been retained, showing the original charm and character of this historic diner. In May 1996, an addition was made to the lunch wagon. The former storage trailer the diner used was physically attached to the diner, making the structure L shaped. Removing the former walk-up takeout window to the right of the entrance allowed access to this new addition. This primarily added much-needed kitchen and food storage facilities, enabling Gilley's to expand its menu by adding French fries as well as other items to go with the hot dogs and hamburgers it already served, according to current owner Steve Kennedy (no relation to William Kennedy).

In 2010, the City of Portsmouth required owner Steve Kennedy and his wife, Gina, to address some issues related to the changed status of the formerly mobile lunch wagon. Now that it was basically nonmovable, the diner did not comply with certain municipal regulations, and the city, not wanting to close down the historic business, allowed Steve and Gina to come up with an expansion plan that would bring the diner into compliance with the regulations. The changes involved a twenty-two- by twenty-six-foot addition to accommodate a larger cooking area (with an automated grease trap removal unit), an employee handicap-accessible bathroom and an office. The project gained approval from the city's Historic District Commission and Technical Advisory Committee with one of the stipulations being the removal of the attached truck.

The menu at Gilley's is fairly simple, although it does offer more items now than it had under previous ownership. There are hot dogs served several different ways, a selection of burgers and French fries that can be ordered several different ways, as well. They also offer something not usually found in this neck of the woods: poutine, a Canadian dish of French fries topped with a light brown gravy and cheese curds. To finish off the menu, there are basic sandwiches, chili and a bowl of beans option. Soups are also offered, but prices and selections vary. Operating hours are Monday through Friday from 8:30 a.m. to 2:30 a.m., Saturday from 11:00 a.m. to 2:30 a.m. and Sunday from 11:00 a.m. to 12:00 a.m.

LION'S CORNER POPCORN WAGON (AKA POPCORN STAND), NORTH MAST ROAD AND HIGH STREET, GOFFSTOWN, NEW HAMPSHIRE

1930s Vintage Wagon

Although this is technically not a lunch wagon or diner, the Lion's Corner Popcorn Wagon located in the area of Goffstown known as the Village could nonetheless be considered a second cousin to the old horse-drawn lunch wagons of the late 1800s and early 1900s. I first photographed it in October 1981, after an acquaintance told me about it. I was excited as he told me there was a lunch wagon in Goffstown. When I got there, I was a little disappointed when I saw that it was, in fact, a popcorn wagon, but because it was so unique, I knew I needed to document it with photos. In planning this book, I felt that the chapter on lunch wagons would not be complete without including this relic that, to my knowledge, still exists. After recently learning that the local chapter of Lions Club International currently owns the wagon, I contacted them to get some info on the wagon. Dave Pierce of the Lions Club sent me this great history and timeline, which he wrote recently:

> *The Popcorn Wagon has been in existence since the 1930s, when it was operated by Louis Prince at the Shirley Station of the trolley line that ran into the Village from Manchester. Nowadays, the trolley line and the station no longer exist, so for the nonhistorian, the station location is what we now know as the southwest corner of the roundabout at the intersection of Wallace Road and South Mast Road. Each night, [Prince] used his Model T Ford to slowly move the hard rubber–tired wagon from his nearby home on Worthley Hill Road to the watering trough beside South Mast Road. Plugged into electricity from an outlet on a utility pole, the stand would shine like a beacon light and beckon to all around. When a customer requested lots of butter, Louie would reply, "You betcha, you betcha."*
>
> *In 1944, the wagon was purchased by Charlie Ray, owner of the land at the corner of High Street and North Mast Road. The wagon was moved from Prince's property to this prominent Village corner, and over time, the wagon became a fixed structure, with electricity and town water. It was reported that one family from Peterborough visited it every Sunday, not missing more than three Sundays in twenty years. Due to its unique location and visibility, the wagon (now referred to as a stand) has also served the*

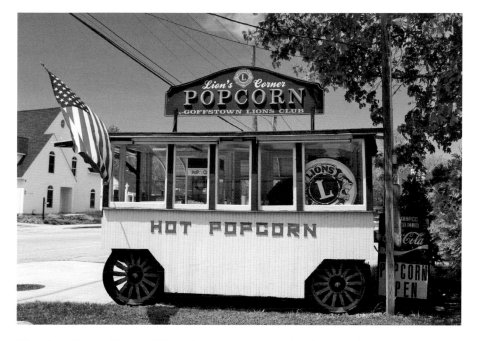

The Lion's Corner Popcorn Wagon has been a local landmark for the better part of eight decades. The local Lions Club purchased this unique survivor to ensure it stays around for future generations to enjoy! *Photo by Larry Cultrera.*

community as a reference point for anyone asking directions to someplace.

On the death of Charlie Ray in 1957, the operation of the stand was taken over by his son-in-law, Donald Worden. Known by his father-in-law's nickname as "Popcorn Charlie," Worden added soft drinks to the menu, followed by the specialty item of his wife, Carolyn: rich, creamy fudge. Each new season, newspaper ads would announce, "Look what has popped up this spring, and we'll be poppin' all summer."

In September 1972, Donald Worden and his wife, Carolyn Worden, purchased the street corner parcel from the heirs of the Ray estate. They continued operating the stand even though they resold the land parcel in June 1976 to Allen and Joan Beddoe, who lived at 9 High Street (now High Street Farmhouse Restaurant).

In May 1980, the operation of the stand was taken over by fourteen-year-old Thomas Finneral Jr., who lived with his parents in Weare. Tom borrowed $1,500 from his father in order to stock up on supplies. Tom expanded the menu with hot dogs and sausages. His parents, Thomas and

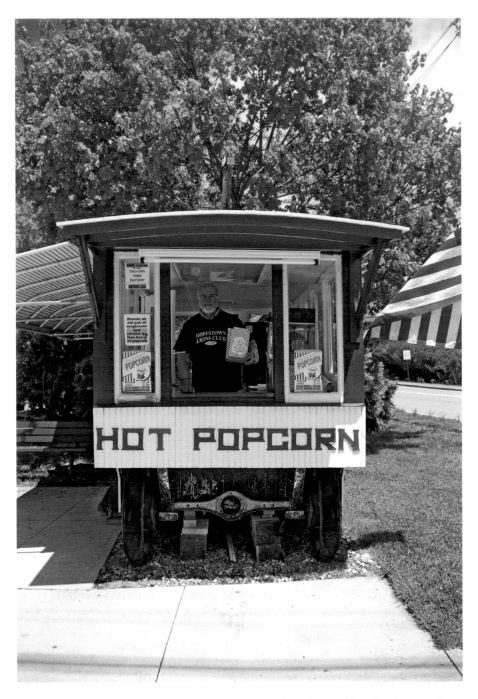

Volunteers such as Dave Pierce operate the wagon on Saturdays and Sundays from mid-May to mid-September. *Photo by Larry Cultrera.*

Ann Finneral Sr., bought the street corner parcel and stand from the Beddoes in June 1984.

Finally, in April 1986, its present owner, the Goffstown Lions Club, bought the land and wagon. Serving buttered popcorn and soda, the members of the club operate the stand on Saturday and Sunday afternoons throughout late spring and into the early fall months. The stand is a "contributing structure" in the list of buildings/structures/sites/objects in the Goffstown Main Street Historic District, which the National Park Service approved in March 2007 for placement on the National Register of Historic Places.

While the stand and the town of Goffstown have experienced many changes since the 1930s, one thing that has not changed is this sure sign of spring and summer: the aroma of "hot buttered popcorn" wafting through the air. Sometimes it's the simplest things in life that can give us the most pleasure.

Founded in 1917 by thirty-eight-year-old Melvin Jones, a Chicago businessman, Lions Club International is a nonprofit organization dedicated to helping improve the community. The club focuses on eye research with a determination to end blindness, which was encouraged by none other than Helen Keller, who addressed the Lions Club International Convention held at Cedar Point, Ohio, in 1925. Miss Keller urged the organization to become "knights of the blind in the crusade against darkness." Since that time, the club has worked tirelessly, fundraising much-needed dollars for eye research. Besides this invaluable contribution to society, the organization looks for other ways to help their respective communities, and the Goffstown chapter felt this iconic popcorn wagon represented an aspect of local history and a part of the town's character that the Lions Club wanted to preserve for future generations to enjoy.

The wagon/stand opens for the season on Mother's Day (usually in mid-May), when it offers free popcorn for all mothers, and continues every Saturday and Sunday from noon until 6:00 p.m. The stand's season ends on a Sunday in mid-September. The menu is about as simple as can be: hot, buttered popcorn and a variety of bottled sodas and water.

2

Longtime Favorite Diners

New Hampshire has quite a few factory-built diners that have been operating for decades. The diners vary widely in age, dating from the 1920s to the 1960s, and cover a range of different styles. This chapter will deal with the locations of these longtime favorites spread throughout the state and talk about their history. We will begin in the northern part of the state and work our way south.

Way up in Grafton County we can find the Littleton Diner, a standard model (non-streamlined) Sterling diner that has been around since 1940. In Lincoln, south of Franconia Notch, there is an extremely rare Master diner currently operating as the Sunny Day Diner that spent its first thirty years in Dover, New Hampshire, prior to moving north. A little farther south, in the college town of Plymouth, sits the mostly preserved Main Street Station Diner, a semi-streamlined Worcester Lunch Car with a mansard roof hiding the original monitor roof along with the HVAC equipment mounted there. Not too far away, Bristol holds another rare survivor. Currently known as the Bristol Diner, this is one of only two Pollard diners still in existence. (There may have been only four built.) The Union Diner of the Lakeport section of Laconia is one of three late model Worcester Lunch Cars in the state (dating from the 1950s) that have spent all their lives here. The Peterboro Diner and Four Aces Diner are the other two. The Hillsborough Diner is the only Kullman diner operating in the state, while Daddypop's Tumble Inn Diner is a one-of-a-kind Worcester Lunch Car from the late 1940s. Lindy's Diner in Keene is the only Paramount Diner in Northern New England as well

as being the only 1960s vintage diner in the state. The Milford Red Arrow Diner, Red Barn Diner and Joanne's Kitchen and Coffee Shop (along with the aforementioned Bristol Diner) are pretty much the oldest diners in the state, while Hope's Hollywood Diner of Plaistow is the only Mountain View Diner known to have been in the Granite State.

LITTLETON DINER, 145 WEST MAIN STREET, LITTLETON, NEW HAMPSHIRE

1940 Sterling Diner

Located "above the notch" in the thriving community of Littleton, the Littleton Diner is one of an ever-dwindling number of Sterling diners still operating in the country. Built by J.B. Judkins Company out of Merrimac, Massachusetts, this company had roots that went back to the mid-nineteenth century. Starting out as a builder of fine carriages and coaches, sometime after the turn of the twentieth century the company went on to build luxury bodies for high-end automobile companies, such as Duesenberg. When the automobile body business dwindled, Judkins retooled and went into the manufacturing of Sterling diners, famous for their Sterling Streamliner (see the list of diner manufacturers in Appendix IV for more information on this company).

The Littleton Diner is one of the standard models (non-streamlined) offered by Judkins with the company's version of the barrel roof, although an added mansard roof has hidden the original roof on this diner for decades. The outside does retain the original porcelain-enameled steel exterior panels with "baked-in" graphics, but more recently, its factory-installed double-hung windows have been replaced with newer ones using the original openings. The interior has gone through some changes over the years as well. The counter is closer to the back wall than the way it was when it was new, providing more room between the booths and the counter for the waitstaff and clientele to move about. Conversely, with the counter moved, the back bar size was also made narrower, and all the cooking was moved to a back kitchen. The building that houses the kitchen also accommodates restrooms and a decent-sized dining room.

Having had several owners over the decades, the original Littleton Diner was purchased for the price of $5,000, by Eugene and Stella Stone in January

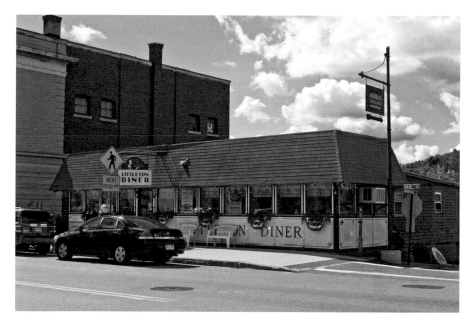

The current version of the Littleton Diner is a 1940 vintage Sterling Diner built by J.B. Judkins Company of Merrimac, Massachusetts. It has been modified over the years but retains most of its classic elements, like the porcelain-enameled exterior panels. *Photo by Larry Cultrora.*

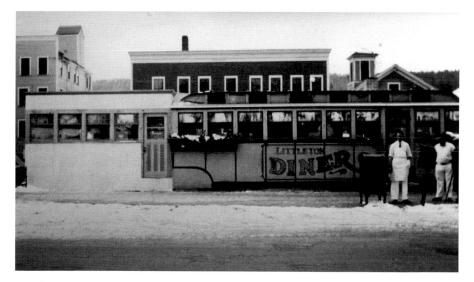

The original Littleton Diner was bought used in 1930 and came from another operating location in Cortland, New York. Built by the Ward & Dickinson Company, this diner had a small addition on the left side and was replaced by the current diner within a decade. *Photo courtesy of Littleton Diner.*

1930. Michael Engle, a diner historian from the Empire State has done a ton of research on the Lake Erie region of New York State, and he tells me that the first incarnation of the Littleton Diner was Diner No. 63, built by the Ward & Dickinson Dining Car Company out of Silver Creek, New York. It was a used diner that had previously been operating in Cortland, New York, when the Stones found it and moved it here. The diner was small, seating only twenty-five with the cooking area right behind the counter. The Stones ran this diner until 1940, when they purchased the current Sterling diner as a replacement. The new Sterling could handle thirty customers initially but was almost immediately expanded just prior to World War II. It was at this point the kitchen was moved from behind the counter to the large addition built onto the rear of the diner. With the reconfigured diner and new dining room, there was now seating for about fifty patrons. The Stones continued to operate the diner as one of their several local business ventures from that time until 1960, when they sold it to their daughter Eileen and her husband, Louis Burpee. The Burpees continued to operate the diner until leaving the restaurant business in 1975.

Since then, the Littleton Diner has changed hands several times. Other owners include Dennis Fekay, who had the diner for eight years (from 1975 to 1983). Fekay sold it to Joe Howe, who ran it for about a year before the reins were taken over by Earl Tilton. The owners from March 1992 until June 2003 were Bobbie and Everett Chambers. Under this ownership, Chris Williford was the manager of the diner from 1997 to 2003. In June 2003, Chris and Patti Williford purchased the diner to continue the long tradition of serving good food at reasonable prices in a friendly atmosphere. Their slogan is "Where There's Always Something Cookin'!" and it seems you can take them at their word judging from their operating hours and menu. The Littleton Diner is open Monday through Sunday from 6:00 a.m. to 8:00 p.m., serving breakfast, lunch and dinner.

SUNNY DAY DINER, ROUTE 3, LINCOLN, NEW HAMPSHIRE

1958 Master Diner

The Sunny Day Diner could almost qualify as being in the "Transplanted Diners" chapter, but because the diner has always operated in New Hampshire (to my knowledge), I decided to talk about it here in the "Longtime

Favorites" chapter instead. The Sunny Day Diner is a very rare example from the Master Diner Company of Pequannock, New Jersey, and it could be the Master diner car that has traveled the farthest north. Its first known operating location was 523 Central Avenue in Dover, New Hampshire, where it traded as Stoney's Diner from 1958 into the early 1980s. For a brief three or four years, until it closed there, it operated as Gilmet's Diner. I visited this diner quite a few times in the early to mid-1980s, under both the Stoney and Gilmet names, usually for breakfast, although I do remember an instance when I stopped for lunch with my late mother on a scenic ride. I also recall taking a Sunday morning ride circa 1987 to have another breakfast at Gilmet's, and as I was pulling up to the site, I noticed a "For Sale" sign on the diner's roadside sign. This did not bode well, and when I went to turn into the parking lot, I was surprised to see that the diner was gone! I spotted a local traffic cop and inquired as to the diner's fate. He told me it was torn down. I was certainly disappointed and noted another unfortunate loss.

Fast-forward to early 1988, when my friend Steve Repucci informed me that in his recent travels, he came across a diner in Lincoln, New Hampshire, that was being installed on Route 3 near Clark's Trading Post. As he described the diner to me, I thought the place sounded familiar and became curious. So I made the journey north shortly thereafter to see for myself, and I was surprised and happy to discover that it was the former Stoney's/Gilmet's Diner back from the dead! I did get to speak with the new owner, whose name was Jay Bartlett. Jay was busily preparing the diner for reopening. One huge difference to the exterior was the addition of a "barrel roof" over the diner's original "monitor roof." I asked Jay about this. He claimed the roof was in bad shape and was leaking, so to protect the building, he had the newer roof built over the original. Other than that, the exterior has kept its original look with the plain stainless steel panels that came from the factory. A new large kitchen/restroom addition was built on the back while the interior of the diner was also kept in pretty much its original condition.

Jay operated the diner for a number of years and then sold the business to Bruce and Chris Balch, along with partner Kelley Ann Kass, in 1997. That is when the name changed to the Sunny Day Diner, and it has been called that ever since. The Balches and Kass were known for their baked goods—so much so that customers were raving about them! In August 2004, they sold the diner to the current owner Loucas Tserkezis, who has continued the tradition of excellence that his predecessors began. Tserkezis himself is an accomplished pastry chef and baker, having honed his skills in a few New York City–area restaurants. All breads and baked goods are produced in

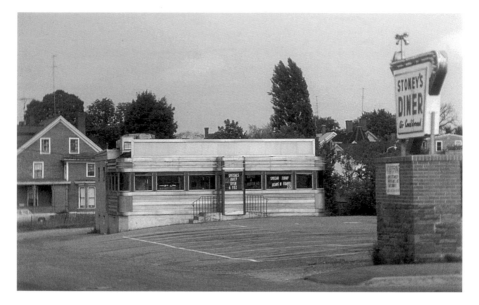

The Sunny Day Diner was originally located in Dover, New Hampshire, and had operated under names such as Stoney's Diner (as seen in this photo) and later as Gilmet's Diner prior to being moved to its current location in the late 1980s. *Circa 1981, photo by Larry Cultrera.*

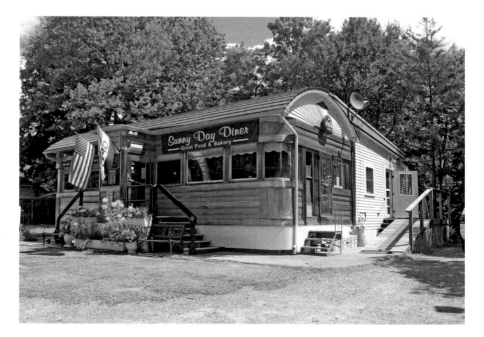

The Sunny Day Diner as it looks today with the added-on "barrel roof." When it was installed here, it was known as Jay's Sweetheart Diner. *Photo by Larry Cultrera.*

the full bakery housed in the basement of the diner. Tserkezis says that no commercial mixes go into anything he makes on premises. Even the pancake batter is completely made from scratch.

Serving breakfast all day as well as lunch, the Sunny Day Diner's regular operating hours are Friday, Saturday and Sunday 7:00 a.m. to 2:00 p.m. from September through June. In July and August, it is open seven days a week. The diner is also open all seven days of the Laconia Motorcycle Week.

MAIN STREET STATION DINER, 105 MAIN STREET, PLYMOUTH, NEW HAMPSHIRE

1946 Worcester Lunch Car

The Main Street Station Diner of Plymouth (aka Worcester Lunch Car No. 793) started out its life as Fracher's Diner. The car is an increasingly rare example of the semi-streamlined style that Worcester was famous for. Delivered to this location brand new on September 9, 1946, it was built for Edmund L. Fracher, whose name still adorns the exterior. This diner came with a door centered in the front façade as well as one on the left-end wall, although it seems that the side door has never been used as it sits high up off the ground with no apparent stairway. The diner has the ever-present "Booth Service" and original "Fracher's" name baked right into pale yellow porcelain-enameled steel panels. The graphics are red with a dark drop-shadow, one red stripe at the top under the windowsills and red stripes on the bottom of the corner panels.

When I first photographed this diner circa 1981, it was called B.J.'s Diner. At that time, the porcelain panels were covered over with brick, and the roof was covered with a wood-shake mansard roof. It later operated as the Trolley Car Restaurant for a few years prior to acquiring the current name. The brick was eventually removed in the mid- to late 1990s, exposing the panels again, while the mansard roof has been retained (now covered in standing-seam metal). The mansard hides the HVAC equipment that has been mounted on the roof of the diner. Trish and Bob Bourque are the owners who removed the brick and updated the mansard roof sheathing. In 2008, the Bourques sold the diner to Steve Luce of Laconia, and he, along with his family, continued to operate the business as the Main Street Station. The diner is a popular place for breakfast and lunch, and breakfast is served all day, everyday—the mark of any good diner in my opinion!

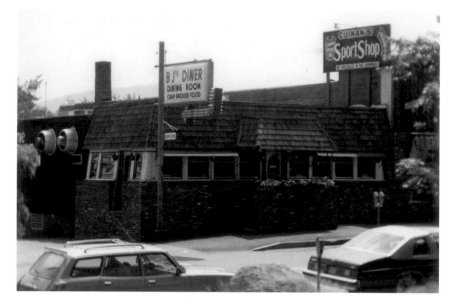

Main Street Station Diner was operating as B.J.'s Diner in the early 1980s. The exterior had been disguised sometime earlier with a wood-shake mansard roof and brick façade, as this photo shows. *Circa 1981, photo by Larry Cultrera.*

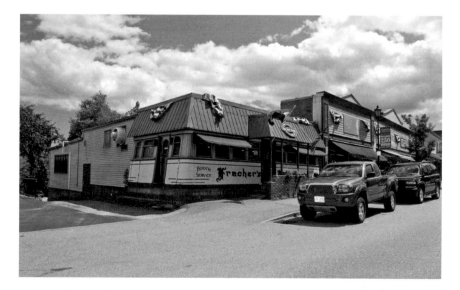

In the 1990s, Main Street Station had a slight retro makeover when the brick façade was removed to expose the original porcelain panels with the name "Fracher's" on them. The wood-shake mansard was updated at the same time to a standing-seam metal sheathing. *Photo by Larry Cultrera.*

The business changed hands again when the Luces sold the diner to Dori Dearborn in January 2014. I contacted Dori recently, and she is excited about carrying on the tradition of providing good food from this classic Worcester Lunch Car. She has kept pretty much the same menu that the Luces had but does have plans to make some changes and/or additions as time goes on. Dori told me in a recent communication: "The diner is doing well, and we're looking at a new menu (old favorites will stay)." The Main Street Station Diner serves all-day breakfast and lunch, and starting on May 19, 2014, the diner is open seven days a week from 7:00 a.m. to 3.00 p.m.

BRISTOL DINER, 33 SOUTH MAIN STREET, BRISTOL, NEW HAMPSHIRE

1926 or 1927 Pollard Diner

According to research by Gary Thomas (*Diners of the North Shore*) as well as Richard J.S. Gutman (*American Diner Then and Now*), the Bristol Diner of Bristol, New Hampshire, was originally located at 4 Boston Street in Salem, Massachusetts, current home of Deb's Pilgrim Diner. It was operated at that location by Lawrence Farnsworth, who was also associated with a lunch wagon at approximately 406 Essex Street in Salem, as well as one in nearby Lynn. The Bristol is one of only two surviving diners built by Pollard and Company of Lowell, Massachusetts; the other is the Palace Diner in Biddeford, Maine. From what I can gather, the diner probably left Salem either before or around the time that the Pilgrim Diner was delivered in 1936. It seems at that point, Farnsworth moved the diner to 217 Main Street in Stoneham, where he renamed it Larry's Diner. It is reported the diner left Stoneham after a short stay and was moved to Bristol, New Hampshire, circa 1937, where George Totas reopened it as the Bristol Diner. In 1962, Joseph and Nancy Hannagan purchased the diner and renamed it the Ricky-Joe Restaurant after their sons. The Hannagans sold the restaurant in 1967. When the Hannagans purchased it, the diner had already been incorporated into a much larger building, making it kind of hard to tell there was even a diner lurking inside. The front wall was covered with wooden shingles, the front windows had been changed and there was a mansard roof installed to connect the diner to the building behind it, completely obscuring the barrel roof.

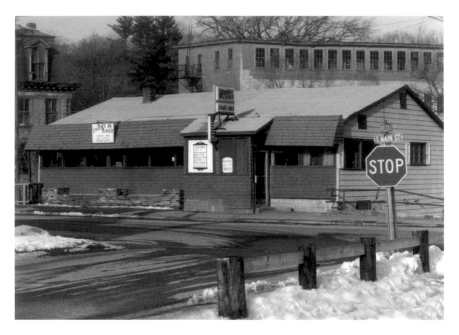

Operated as the Bristol Diner for decades, this place went under a few ownership and name changes from the early 1960s until the current ownership took over. Here the place is somewhat disguised and being run by Harry & Cindy Spain as Spain's Diner. *Circa 1983, photo by Larry Cultrera.*

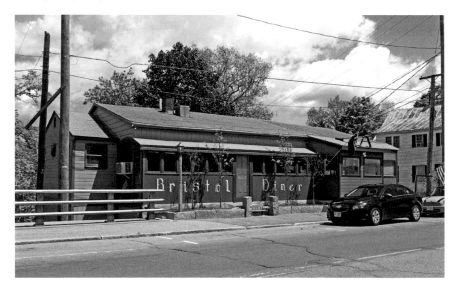

Current owners Jerry and Tina Nialetz restored the Bristol Diner name back to the business when they bought it in 2006. A former owner, Chris Stamnas, had previously uncovered the diner so it could be seen again from the outside. *Photo by Larry Cultrera.*

From 1972 to 1986, this small diner with counter seating and a dining room addition was owned and operated by Harry and Cindy Spain as Spain's Diner. Right after the Spains, Agnes and Dick McLellan took it over. The McLellans had previous experience operating diners in the Lakes Region, including the Paugus Diner and Shore Diner in Laconia. The diner's name was changed around this time to the Riverside Diner. A new owner by the name of Chris Stamnas took over in the early 1990s. Stamnas is credited with restoring the exterior of the diner by uncovering the front portion of the barrel roof and installing new windows that replicated the originals, making the diner visible again. Current owners Jerry and Tina Nialetz took over the diner in 2006 and brought the Bristol Diner name back. They even replicated the Old English lettering on the front façade that appears in an old photograph. In the spring, summer and fall, weather permitting, the diner makes good use of the outside deck for al fresco dining.

Bristol Diner is open for breakfast and lunch Monday through Thursday and Saturday through Sunday from 7:00 a.m. to 2:00 p.m. On Friday, it is open from 7:00 a.m. to 8:00 p.m., serving dinner as well. The only day it closes during the year is Christmas Day.

UNION DINER, 1331 UNION AVENUE, LACONIA, NEW HAMPSHIRE

1951 Worcester Lunch Car

The Union Diner is Worcester Lunch Car No. 831. According to Worcester Lunch Car Company records, it was originally delivered on May 17, 1951, and installed at 21 School Street in Concord, New Hampshire, where it traded as the Manus Diner under the father-and-son team of Peter and Markos Manus. The diner has plain porcelain-enameled steel panels with a rare base color of dark green. The only graphics baked into the panels is the rather broad yellow stripe at the top under the windowsills and also near the bottom of the corner panels. It also sports the ubiquitous "Booth Service" panels on either end of the front façade.

According to Laconia business directories, the diner was sold to Milton and Paul Christy and moved circa 1968 to Union Avenue in the Lakeport section of Laconia. The Christys operated it as Paul's Diner until 1977. When the diner came to Laconia, it was installed sitting end-ways to the street, meaning the left-

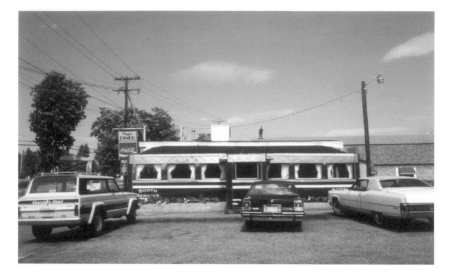

Operated for many years as the Paugus Diner, here we can see the building the way it looked from when it got here in the late 1960s right up until the mid-1980s. In 1986, the diner was relocated on the same property to accommodate a new shopping plaza. *Circa 1983, photo by Larry Cultrera.*

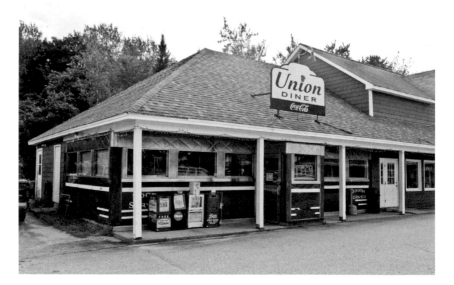

Here we see the same diner as it currently sits incorporated into Union Port Plaza. Renamed in 2009 as the Union Diner by current owner Rose Pucci, this place is still a popular breakfast and lunch destination in the Lakeport neighborhood. *Photo by Larry Cultrera.*

side wall of the diner faced Union Avenue while the front of the diner faced a parking lot that was shared by other buildings off to the right side of the property. There was a cinderblock addition attached to the back of the diner that housed a kitchen and restrooms. Also, according to the business directories, around 1978, the diner was known as Barbara Ann's, but in 1979, the business was renamed the Paugus Diner. I believe that is when it was leased to Carlton and Norma Blackey. The Blackeys ran the diner until 1982, when Carlton passed away. At that point, Norma continued to operate the business for a short time with the assistance of Florence Hutchinson, a relative. After that, the diner was sublet to Agnes and Dick McLellan (Norma Blackey's aunt and uncle) for a time.

A major change was made in mid-1986, when the property was reconfigured into a strip mall called Union Port Plaza. First, the developer demolished the other buildings on the right-hand side of the property, across the parking lot from the front of the diner. Then it disconnected the diner from the kitchen/restroom addition so the diner could be picked up and moved to the back of the lot. During this process, the diner was turned ninety degrees clockwise so that it faced Union Avenue while the old kitchen/restroom addition was demolished. Opening up this part of the property exposed the building that used to be behind where the diner and its addition were. This building now became the eastern portion of the new U-shaped strip mall, fronting on the shared parking lot. The developer moved forward by constructing a new L-shaped building that was unified under one roof with the diner now anchoring the eastern end of the L at the back of the parking lot. Most of the L section of the strip mall has a second floor while the diner just has a "hip roof" built over the original roof. The hip roof overhangs past the front of the diner's entryway vestibule, creating a covered sidewalk common to the other tenants in the building. The Paugus Diner was reopened in 1987.

After the McLellans, the diner was sold to Alan Fullerton, who operated it for quite a few years. In the spring of 1991, during Fullerton's time operating the diner, the structure suffered a fire, which destroyed the original Formica ceiling and other details. Fortunately, it was restored back to pretty much its original looks fairly quickly and resumed serving food. One other change the fire effected was that the cooking area behind the counter was discontinued and moved to the larger kitchen in the back. In 1994, Fullerton was able to add more seating to the diner by annexing the adjacent storefront to the right in the strip mall for a new dining room.

More recently, Fullerton lost the diner to foreclosure, and Rose Pucci purchased it at auction in March 2009, renaming it the Union Diner. A Laconia native, Rose Pucci stated when she bought the diner that she used

to frequent it with her parents when she was young. She had been operating another nearby restaurant when the diner became available, and she jumped at the chance to own and operate a nostalgic piece of her past. One constant at this diner for the last thirty-six years has been Bonnie Noyes. Bonnie is one of Carlton and Norma Blackey's daughters, and she has worked at the diner from the time her family ran it until the present.

Researching the history of this diner brought to mind stories I had heard over the years about one of the more memorable people to work behind the counter here, a gentleman by the name of Spider Osgood. A lifelong resident of Lakeport, he was quite possibly the best grill man in the business. Because of his notoriety, I have devoted Appendix I to Spider.

The Union Diner is open Monday through Wednesday from 6:00 a.m. to 3:00 p.m. and Thursday through Saturday from 6:00 a.m. to 8:00 p.m. Dinner at the diner is served Thursday, Friday and Saturday evenings until 8:00 p.m. Friday nights feature slow-roasted prime rib or an all-you-can-eat fish fry. Breakfast is served every day until 3:00 p.m. The Union Diner has a selection of draft and bottled beer as well as specialty drinks and wines (by the glass). On Sundays, the diner is open from 6:00 a.m. to 1:00 p.m. for breakfast only.

HILLSBOROUGH DINER, 89 HENNIKER STREET, HILLSBOROUGH, NEW HAMPSHIRE

1953 Kullman Diner

The Hillsborough Diner is the Granite State's only operating Kullman diner. It was originally operated as Zeke's Diner when it got here in 1965, and it was named for owner Augustine "Zeke" Barrett. I recently spoke with Zeke's son, Mike Barrett, who told me the diner was bought used and came from Paterson, New Jersey. They were informed that it was a 1953 vintage diner. I asked Mike when the addition for the dining room and restrooms was built, and he related that it happened within five years, around 1969 or 1970. Back then and right up until more recently (within the last twenty years), Henniker Street, where the diner is located, was in fact the main road through Hillsborough. It was designated NH Route 9 and U.S. Route 202 before it was bypassed by a new highway alignment. So the diner was known as a truck stop as well as a local in-town restaurant that was very busy, making the larger seating arrangement necessary.

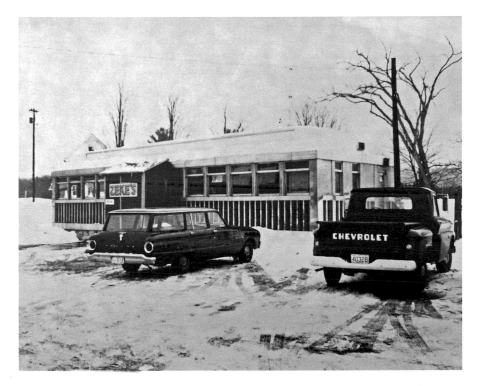

Here we can see Zeke's Diner around the time that it opened for business in 1965. It was purchased by the Barrett family and trucked up from Paterson, New Jersey. This is the only operating Kullman Diner in the Granite State. *Photo courtesy of Hillsborough Diner.*

When it arrived, the diner was pretty much a stand-alone facility. It still featured cooking behind the long counter as well as factory-installed restrooms situated over on the right front area, partitioned off from the main diner. It had an entry door centered in the front façade and was flanked by six windows on either side of the door. When the addition was built, it basically removed almost two-thirds of the left side of the diner. A new entrance was made by removing a window/wall section three windows over to the left of the original door, and if you look closely, you can see that the original front door is still there. A section of red porcelain steel wall panel that had been removed from the exterior of the diner's left side was cut to fit over the bottom half of the door in an attempt to make the door look like a window. In fact, if you sit at the booth that is now where the door used to be, you can see the Kullman manufacturer's tag where it has always been. A good portion of the back bar and counter were removed when the addition

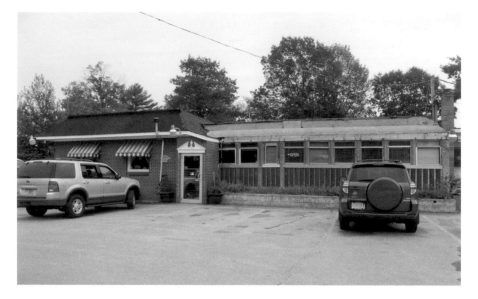

The Hillsborough Diner today showing the addition that houses the dining room and restrooms. This addition was circa 1970, just five years or so after the diner got here. The whole left end of the diner was pretty much replaced by this addition while the rest of the diner is remarkably intact. *Photo by Larry Cultrera.*

was built as well, but there are now larger restrooms and a dining room featured in the new section. The part of the original diner that remains still gives the old-time feel on the interior that one always looks for in a classic old diner. Especially noteworthy is the basket weave–patterned ceramic tile on the floor.

The Barrett family continued to operate the diner until 1980, when they sold the business to John and Joanne Reckendorf, who renamed it the Turning Point Restaurant for a short period. In fact, it was still operating as the Turning Point Restaurant when I found it in October 1982. I have been told that shortly after that, in 1983, Mary Caron bought it and the name changed to Caron's Diner. Caron, who had the longest run operating the diner (twenty-two years), in turn sold it to John Grimanis as of July 2005, and the name was changed again, this time to the Hillsborough Diner. John, wife Antonia and son Nick have been doing a great job of running it for the last nine years, aided by a well-seasoned and friendly staff of servers. The Grimanis family have a long history in food service, primarily in the Greater Boston area. Nick Grimanis told me his dad had wanted to run a diner for years and saw his chance when this one came on the market.

The Hillsborough Diner serves breakfast Monday through Saturday from 6:00 a.m. to 11:30 p.m. and Sunday from 7:00 a.m. to 1:00 p.m. Lunch and dinner hours are Monday through Saturday from 11:30 a.m. to 2:00 p.m. Also, on Wednesday, Thursday and Friday, the diner closes at 2:00 p.m. and reopens again from 5:00 p.m. to 8:00 p.m.

FOUR ACES DINER, 23 BRIDGE STREET, WEST LEBANON, NEW HAMPSHIRE

1952 Worcester Lunch Car

The Four Aces Diner (aka Worcester Lunch Car No. 837) is an extremely well-preserved late-model diner that has had few modifications over the years. The diner was bought by Roy E. Stewart from Worcester Lunch Car and delivered on November 5, 1952, to its first location just up the street from where it currently is operating. From what I know from *Diners of the Northeast*, the 1980 book by Donald Kaplan and Allyson Bellink, the Four Aces used to have a fantastic rooftop neon sign that reportedly went missing in the late 1970s by way of a college fraternity prank and was never recovered. This was certainly a little disappointing to authors Kaplan and Bellink, as it would have been to me. They went on to explain that, by all accounts, that sign was something to see, especially at night, as it depicted four aces that flashed in different colors. By the time I first photographed it a couple years later, on October 1, 1982, it was still at its original operating location at the corner of North Main and Dana Streets; however, the diner had a plain backlit electric sign on the roof, which was not much of a replacement for the neon extravaganza that preceded it. The diner also featured a dining room symmetrically added on to the left end of the diner.

Phil and Dot Gomez purchased the diner in the mid-1960s and operated it until 1986. The Gomezes sold the diner at that time to Phil Manns and Jim Burnham, who turned around and sold the property and then moved the diner to the current location on Bridge Street, pretty much within sight of the former location. After it was installed there, a building was built around and over the diner so that the only exterior part of the diner that is visible is the front wall and entryway. The interior is wonderfully intact, and there is now a dining room on the left side again with a small hallway on the

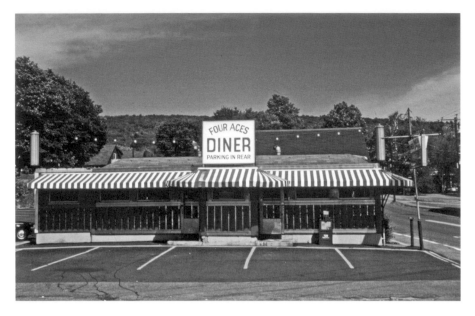

The Four Aces Diner at its original location just up the street from where it now lives. Within a year or so of when this photo was shot, the diner was moved to its current location. *Circa 1985, photo by Larry Cultrera.*

This photo shows the Four Aces Diner as it now is, completely surrounded by a new building with only the front façade of the diner exposed. *Photo by Larry Cultrera.*

right side leading to restrooms. Holly and Jim Burnham operated the diner for a short time. I spoke with Holly Burnham, who related a story about Phil Gomez asking for the keys to the diner every now and then. Handing him the keys, Holly would ask him what he needed to get in the diner, and he would answer, "Never mind." She would come in the next day, and the ceiling panels would be all shiny and clean from the thorough scrubbing Mr. Gomez had done on the previous day. Apparently, Mr. Gomez still loved the diner and did not like to see the condition of the ceiling looking a little shabby from cooking and infrequent cleanings. The Burnhams sold the diner to the current owners, the Shorey family, who in turn leased it to the Salls family in 1989. The Sallses ran it until April 1991, at which time the Shoreys decided to take over the operation. Steve Shorey operated the diner with his sister Leann Briggs from then until July 1996, although as Briggs states, her brother remained involved with the operation after they leased it to Richard Clark, who was the operator for about ten years. After Clark, the diner was closed for a while and then leased to Molly Dennis, who was there just about a year. She closed in October 2010. The diner was reopened in February 2011 under "old management" (meaning the Shorey family with Briggs again involved).

The Four Aces Diner's menu is another pretty typical example, especially for breakfast and lunch, although I will say they've mixed in some items to make things interesting. Breakfast is served all day here, and Leann Briggs tells me that they are known for their corned beef hash as well as their red flannel hash. When we were last at the Four Aces in April 2014, we noticed they actually made their own doughnuts and baked goods. Another item on their menu that I have not seen at any other diner is something called "bubble and squeak." A dish that has Irish and English roots, the Four Aces' version is described as a hash of cabbage, potato, ham, bacon and onion. This is served with eggs, toast and home fries, or you can get it with baked beans and a biscuit.

The Four Aces Diner takes pride in being a member of the Local First Alliance, using products from local businesses such as King Arthur Flour Company, White Mountain Gourmet Coffee, Taylor Brothers Maple and Cheese and North Country Smokehouse. Current operating hours for the Four Aces Diner are pretty simple: Monday through Saturday 5:00 a.m. to 3:00 p.m. and Sunday from 7:00 a.m. to 3:00 p.m.

DADDYPOP'S TUMBLE INN DINER, 1 MAIN STREET, CLAREMONT, NEW HAMPSHIRE

1941 Worcester Lunch Car

Debbie Carter bought the Tumble Inn Diner in October 1996. After taking a few weeks to perform some much-needed cleaning and prepping of the diner, she reopened it for business on January 20, 1997. Carter added "Daddypop's" to its name in order to make a connection with her dad's place back in Pennsylvania. Her dad, Ken Smith, is the owner/operator of the extremely popular Daddypop's Diner of Hatboro, Pennsylvania. Some may think the name Tumble Inn itself is kind of unique, but historically, I know of at least four other diners that had the same name, with all the other ones being in Massachusetts. In fact, all except one of those started out in Worcester Lunch Car Company–built diners. Only one of those others is still around and operating now in my hometown of Saugus, although it has been housed in a regular storefront since the late 1950s or early 1960s.

Built by Worcester Lunch Car in 1941 as Car No. 778, this diner is a one-of-a-kind model that was based on Worcester's popular semi-streamlined design with one physical exception—it did not have the "slanted end walls" that were prominent on the other streamliners. (Main Street Station in Plymouth is the only example of a Worcester streamliner operating in the Granite State that has the slanted end walls.) There were other custom details that were featured in this diner, such as the more expensive and rarely used ceramic tile floor design as well as the fancier stained-glass upper portions of the double-hung windows that also showed up in the Rosebud Diner of Somerville, Massachusetts, among others. The porcelain-enameled steel panels featured a baked-in graphics design never used before or after this diner. The diner itself is in original condition even though it has had quite a few operators since it was new. The original owner was listed as Angelo Baldasaro, according to the Worcester Lunch Car Company records. I recently visited the diner and spoke with Debbie Carter, who gave me a list of some of the other people who had been associated with the Tumble Inn over the years. These include John Stone, Brenda Rabiero, Larry Beswick, Bill and Susan Durfey and finally Wanda and Larry Paris. The Parises also operated a taxicab company out of the diner and had it designated a Vermont Transit bus stop/ticket agent during their ownership.

Regular operating hours are Mondays and Wednesdays through Saturdays from 6:00 a.m. to 2:00 p.m. and Sundays and Tuesdays from 7:00 a.m. to 2:00

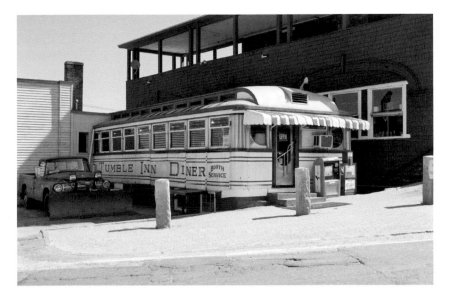

Daddypop's Tumble Inn Diner still looks pretty special nestled into this corner in downtown Claremont. The bright white panels with red graphics make it stand out in this old mill city hard by the Vermont border. *Photo by Larry Cultrera.*

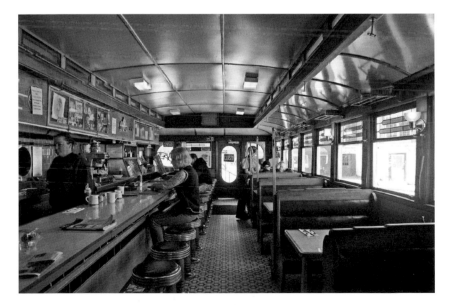

The interior of Daddypop's Tumble Inn is one of the best examples of a top-of-the-line Worcester diner. It is truly a sight to behold with its blue ceramic tile on the walls and counter apron as well as its stained-glass windows and wonderful wood trim. The floor tile is an unusual design as well that was only installed in a small handful of Worcester diners. *Photo by Larry Cultrera.*

p.m. Daddypop's Tumble Inn Diner offers food delivery in the Claremont area Tuesday through Friday from 7:00 a.m. to 1:00 p.m. Although suspended for the summer, the delivery service will resume in the fall.

LINDY'S DINER, 19 GILBO STREET, KEENE, NEW HAMPSHIRE

1961 Paramount Diner

A large number of factory-built diners in New Hampshire were products of the Worcester Lunch Car Company with manufacturing dates ranging from the 1920s to the 1950s. But there are still quite a lot of examples dating from the 1950s manufactured by companies from the Mid-Atlantic region represented as well, with most of those diners coming from the New Jersey–based Jerry O'Mahony Company.

There is one that stands out not only because of who manufactured it but also because of when it was built and delivered. Lindy's Diner is the only diner in the Granite State that dates to the 1960s as well as the only one in the state built by Paramount Diners of Haledon, New Jersey. Bought in 1961 and transported to Keene by the Chakalis family, according to the history written on the diner's website, it is said that many longtime customers can tell you that they personally watched the diner transported into town on a flatbed truck and lifted onto the foundation. The diner history goes on to say that many of the diner's older customers also claim that they helped with the construction of the kitchen addition.

In 1973, the diner was sold to George and Arietta Rigopolous, who were relatives of the Chakalis family. During the Rigopolouses' years of ownership, the diner became a "must stop" for political candidates on the presidential campaign trail to visit for a meet and greet/photo op. It is rumored that if you do not visit Lindy's Diner as a presidential candidate, you will not win the New Hampshire primary. Over the years, there have been some changes to the interior of the diner, including a dropped ceiling and equipment updates, but some original fixtures are still present within the diner as well.

In 2003, Nancy Petrillo and Chuck Criss bought the diner from George and Arietta to continue the tradition of serving good food to the many local customers as well as visitors to this college town. Petrillo and Criss have years of experience in the hospitality industry and decided to bring their talents

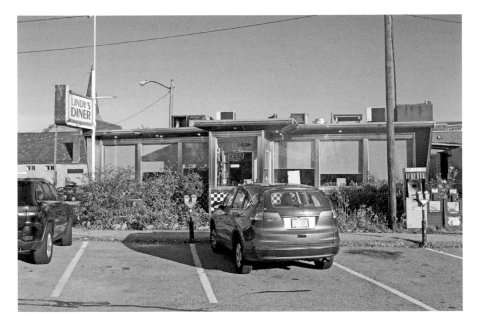

Lindy's Diner in Keene is the only diner in the Granite State that was manufactured in the 1960s. It is also the only one in the state that was built by the Paramount Diner company of Haledon, New Jersey. The latest owners did a slight update on the exterior replacing the white formstone that was on the façade with flat black-and-white checkered panels. *Photo by Larry Cultrera.*

to bear in the operation of an old-style diner. They have made additions to the place, such as a patio for outdoor dining and gardens that the patrons enjoy—as do the local birds and butterfly population. The exterior was updated when the current owners took charge with changes that include the removal of the original white formstone covering under the large plate glass windows. Criss and Petrillo are always contributing to local nonprofit organizations, either through gift certificates and donations or personal time. Nancy Petrillo is on the Keene Greater Downtown Board of Direction and Organization, established to keep downtown vibrant and viable. The diner features a community bulletin board in the foyer advertising activities, entertainment and education happenings in the downtown area. Keene State College's film society usually films once or twice a semester at the diner, and this means one or both of the owners usually stay at the diner after hours, often times until the wee hours of the morning. They offer free space for various nonprofit organization members to be outside the diner to sell tickets to events or raffle tickets for their organizations. During downtown events—

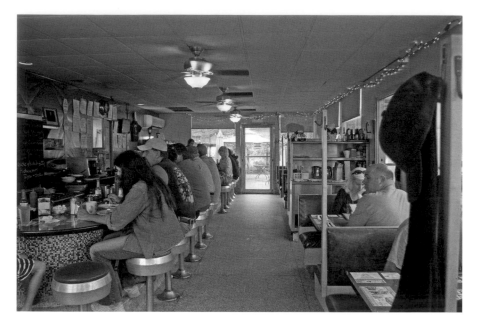

Lindy's interior has survived fairly intact with the exception of a "drop-ceiling" along with new light fixtures and ceiling fans. *Photo by Larry Cultrera.*

art walks, Music Fest, Ice Fest, Punkinfest, to name a few—there are usually people in the gardens or on the patio.

The menu at Lindy's is well appointed with breakfast, lunch and dinner selections that are available any time of the day. A customer can always have breakfast at Lindy's—you can have it for dinner, or you can have dinner for breakfast, whichever you prefer! Lindy's Diner is open daily at 6:00 a.m. Sunday through Thursday and stays open until 8:00 p.m. On Friday and Saturday, the diner is open until 9:00 p.m.

PETERBORO DINER, 10 DEPOT STREET, PETERBOROUGH, NEW HAMPSHIRE

1950 Worcester Lunch Car

The town of Peterborough's history with diners goes back to the lunch wagon days. In the early part of the twentieth century, there was a lunch wagon

located on Grove Street, operated by Frank and Dora Ryan. Originally horse-drawn, this wagon appears in a photo in which it looks to be sitting stationary on the sidewalk in front the buildings that now house Peterborough Shoe Store and Nonie's Restaurant and Bakery. In 1936, the Ryans bought a used diner from the Worcester Lunch Car Company (No. 549) that had previously been operated in Waterville, Maine, as Art's Filling Station. This diner was bought to replace the old lunch wagon and was moved to a new location around the corner on Depot Street. Ten years later, Frank Ryan sold the diner to Milton Fontaine, who operated the old diner until 1950, when he replaced it with the current diner, which he bought brand new from Worcester Lunch Car. (The older diner went on to eventually become the Ever Ready Diner of Providence, Rhode Island, for many years. It survives to this day and is on display at the Culinary Arts Museum located at Johnson & Wales University's Harborside Campus in Providence.) In 1955, Milton sold the diner to his brother Edward.

The current Peterboro Diner (Worcester Lunch Car No. 827) is best described as a great surviving example of a late-model Worcester Lunch Car. The porcelain-enameled steel panels have a dark green color that was repeated on the Paugus Diner a few years later. The only difference is that the Paugus (originally the Manus Diner) did not have its name baked into the panels while the Peterboro Diner sports its name in the typical Old English lettering Worcester was fond of using. I first visited this diner in the early 1980s, when it was still owned and operated by Edward Fontaine. The diner was a perfectly preserved stand-alone lunch car with the grill in sight behind the counter and an auxiliary kitchen that was partitioned from the dining area on the right-hand end of the building. By 1983, Edward Fontaine decided to retire, and the diner was sold to partners Doug Bartlett and Don Merwin, who immediately made changes. They removed the partition and auxiliary kitchen and added new booths (replicating the originals) in this section and a large addition off the back of the diner. The large addition had room for a new kitchen and restrooms as well as more seating. They also removed the grill and adjacent workstation and cut a door to the new kitchen. I was initially not too happy with the changes, but as the years have gone by, I have mellowed. I feel this place has a great small-town diner ambience that most people look for, even with all the changes. Since then, there have been upgrades to newer generic booths and more recently to newer windows. Some equipment has been changed/removed, and the ceramic tile on the floor and walls were removed. The original tile walls were notoriously not well insulated (read energy efficient), so now the walls have

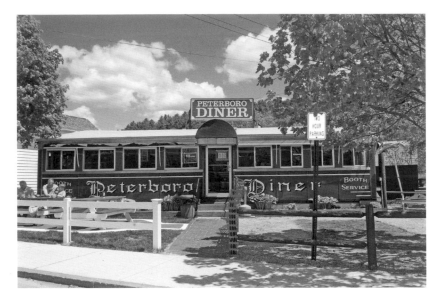

The Peterboro Diner still looks pretty much the same as it always has, although it now has a large building added onto the back that includes more dining and kitchen space as well as restrooms. The front lawn was added in the last twenty-five years or so, and all the original windows were changed. *Photo by Larry Cultrera.*

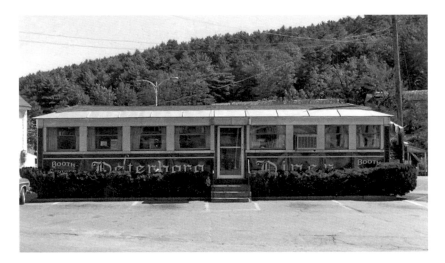

When the Peterboro Diner got here in 1950, it had parking spaces right in front and was completely self-contained with no additional buildings attached. There was a partitioned-off area on the right end of the diner that housed an auxiliary kitchen. The partition and kitchen were removed right after the Fontaine family sold the diner in 1983, when the large addition was built on the back. *Circa 1982, photo by Larry Cultrera.*

insulation and a new covering. Originally, there were "head-on" parking spaces for five vehicles directly in front of the diner. A reconfiguration of the street side with curbing and sidewalk happened in recent years, resulting in those parking spaces being replaced by a small front lawn on either side of the walkway to the diner's front door.

In 1984, the diner was sold yet again to Theofanis and Jane Athanasopoolos and Andy and Stacey Pirovolisanos, who held a grand reopening on April 23, 1984. In August 2003, New Hampshire natives Patrick Healey and Eric Finley bought the diner. The pair had years of experience in food service and decided to put their skills to good use operating their own place. By May 2008, Patrick Healey became the sole owner/proprietor and has continued with the tradition of offering quality food at a great price.

The Peterboro Diner serves breakfast, lunch and dinner during the spring and summer (April to the end of December) when the operating hours are 7:00 a.m. to 7:00 p.m. During the winter months (from January through the end of March), its hours are 7:00 a.m. to 7:00 p.m., Tuesday through Saturday. On Sunday, the diner is open only until 4:00 p.m. and Monday only until 2:00 p.m.. Beer and wine are available.

MILFORD RED ARROW DINER, 63 UNION SQUARE, MILFORD, NEW HAMPSHIRE

1920s Liberty Diner

Since the 1930s, the diner currently known as the Milford Red Arrow Diner has held down this piece of property hard by the Souhegan River, just across from the town green in Milford, New Hampshire. Known for decades as the Milford Diner, its history goes back even further to the horse-drawn lunch wagon days. In researching this book, I contacted David Palance, president of the Milford Historical Society. He and town historian Polly Cote provided me with some background. It starts with the small building that is located directly on the corner of the Stone Bridge and Bridge Street. This is the building that the current diner is attached to. Originally called the Sabin Building, it was built or moved to its current location by the Morse and Kaley Mills when the new town hall was to be built (town hall was built in 1870). This was the year Eagle Hall was moved, Middle Street was created and many other buildings were moved around town to create the room

needed to build the new town hall. In the early years, it was used variously as Mrs. Sabin's variety store, the barbershop of Mr. Adams and a cobbler shop. From 1892 to 1907, Mrs. Knowlton ran the "Ladies Exchange" at this site. In 1913, John Smith purchased the building and enlarged it.

The early lunch wagon that preceded the current diner was credited to Mr. Sidney Baker, who purchased it circa 1900. He parked it on Middle Street during the day, hitched a horse to it in late afternoon and transported it to the road on the north end of the common, where he opened up for business. The lunch wagon at that time was strictly for night trade. Fred Wilkins and Ernest Peabody purchased the lunch wagon from Mr. Baker in 1903, but at some point, Mr. Wilkins became the sole proprietor. Mr. Wilkins's wife baked desserts and pies at home, and their young nephew Raymond Wright brought the desserts to the wagon. Pies that were sold at the wagon for local church fairs cost twenty-one cents. By 1911, the town demanded that the lunch wagon no longer be parked near the common. Levi Barney purchased the wagon and moved it to a platform built between the last block and the Stone Bridge on the west side of the common. In 1913, the wagon was sold to Leslie Marshall and moved next to John Smith's diner (the former Sabin building). In 1916, Mr. Marshall bought the land from Maurice A. Goldman that at that time was just a steep bank and the small former Sabin building that adjoined the wagon. He cut the wagon in two, enlarged it and rented the small Sabin building. Mr. Marshall purchased the new diner built by Liberty Dining Car Company out of Clarence, New York, in 1931, and he connected the diner to the old Sabin building and remodeled it into the Milford Dining Room.

After a few years, the dining room was again rented to hairdressers. The diner was a popular place but was still only a night business until after Leslie Marshall sold it in August 1946 to Andrew Raymond of Amherst. It seems that Mr. Raymond was not too successful, and the property was sold at foreclosure to Wilfred and Hazel Roulx in June 1950. They in turn sold it a year later to George and Gladys Perry. The Perrys operated the diner until March 1960, turning over the reins to Winston and Elizabeth Daniels. The beginning of 1972 saw still new owners in Aman and Kathleen DuFault. By 1979, the old Sabin building was again used as a dining room for the diner. A lounge called the "Stonecutter's Lounge" was built at the rear of the diner as the décor at that time featured Milford granite. By 1988, the diner was owned by Larry and Linda Platte, who operated it into the early 1990s. Other names associated with the diner include Howard Crooker (not sure when he had it). Around 2005, the diner had closed and was bought by Erin

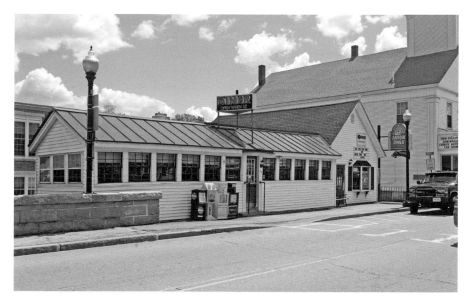

The Milford Red Arrow Diner has looked pretty much like this for years. In fact, I have never been able to find photos of this diner when it did not have the peaked roof hiding the original monitor roof. It is one of my favorite settings of any New Hampshire diner. *Photo by Larry Cultrera.*

The interior of the Milford Red Arrow will look familiar to anyone who has frequented the diner from the 1930s to the early 2000s. *Photo by Larry Cultrera.*

Trip and Arthur Martel. They completely gutted the interior of the diner and operated the ill-fated Toro Restaurant out of the space in early 2006. It operated for only a short time as Toro before it was closed yet again. In 2007, Debbie Flerra and her friend Gordon Maynard bought the diner and brought the interior back to pretty much the way it was prior to Toro. They returned the name back to Milford Diner and operated it from October 2007 to July 2008, when Mr. Maynard died in an automobile accident. After this unfortunate occurrence, Flerra ended up closing the diner. This closing was short-lived, however, when in October 2008, the Milford Diner became the second Red Arrow Diner. Like the Red Arrow in Manchester, the Milford one is open 24/7 and features the same menu.

RED BARN DINER, 113 ELM STREET, MANCHESTER, NEW HAMPSHIRE

1920s Worcester Lunch Car

The Granite State has but a handful of 1920s vintage diners left. Located in Manchester, one of those is the Red Barn Diner, although other than the name, you would not know it was a diner to look at it. From the outside, it looks like a regular medium-sized building that doesn't even remotely resemble a factory-built diner. But when one walks through the front door, about three to four steps in, you actually walk into the original diner, which is completely enveloped by the larger building that houses it. This very small barrel-roofed Worcester Lunch Car more than likely is the remains of what was termed a "10-stooler." Reportedly placed at this location circa 1930, the diner has had many additions over the years. The counter with stools, though not original, is probably exactly where it has always been, although it is now lengthened into an L shape, extending into the dining room to the right of the diner's original footprint. One of the most obvious changes is that the original front wall was opened up with a few columns holding up the front edge of the barrel roof. But pretty much nothing else remains of this diner from the way it came out of the factory. There are tables and chairs in the area between the existing front wall and where the original front wall would have been.

This diner has had a few owners and operating names over the years, although the names of these are lost to time. Its most recent name was

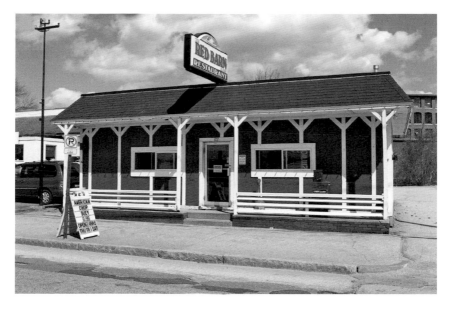

The Red Barn Diner nowadays does sort of resemble a barn more than a diner, especially the exterior. But stepping inside the building will tell a completely different story. *Photo by Larry Cultrera.*

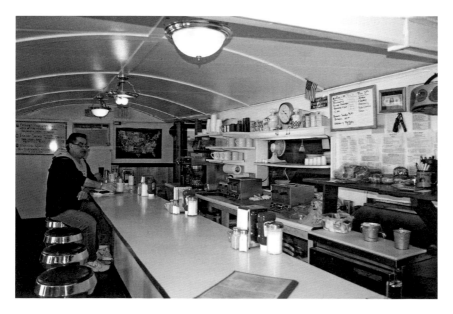

Once inside the Red Barn Diner, the original shape of the small barrel-roofed 1920s vintage diner becomes evident. The current owners have brightened the interior with light colors making the place more inviting. *Photo by Larry Cultrera.*

Shirley D's Diner. Shirley sold the diner to the current owners, Bob and Jean Barton, in June 2007. Renaming it the Red Barn Diner, the Bartons have slowly but surely made some subtle changes over the intervening seven years. They have changed the color scheme on the outside from white with dark trim to red with white trim. The interior seems brighter as well. It was doing a brisk business when I visited it recently, and I was happy to see that the regular customers really seem to appreciate the good food and service here. The Bartons have also reintroduced some longer hours to the diner with the place being open around the clock Thursday through Sunday.

At the Red Barn Diner, breakfast is served all day while the lunch and dinner menus are served after 10:30 a.m. For a small place, its menu offers a little bit of everything and is quite extensive. The operating hours are from 5:00 a.m. to 8:00 p.m. on Mondays, Tuesdays and Wednesdays. Then the diner is open twenty-four hours a day from 5:00 a.m. Thursday to 4:00 p.m. Sunday.

JOANNE'S KITCHEN AND COFFEE SHOP, 219 MAIN STREET, NASHUA, NEW HAMPSHIRE

1920s Worcester Lunch Car

Joanne's Kitchen and Coffee Shop is one of the oldest diners in New Hampshire. A narrow 1920s vintage Worcester Lunch Car that sits endways to the street sandwiched between two buildings, it was originally built with counter service only, but at some point in the past, approximately 99 percent of the diner's front wall (the wall that faced a small alley on the left) was removed and an addition was made to widen the diner, taking up the small alleyway and providing just enough room for some booths. The original counter, ceramic tile floor and stools are still extant. The back bar has been changed, although the old Monel metal grill hood has been retained, but all the cooking is done in the back kitchen now. In fact, that Monel metal hood is one of the longest ones I have seen from this period. When the front wall was removed to make room for the new addition with booths, a new entrance was made in the widened building. As you walk into the front door and look to the right, there is one original window remaining from that old front wall. It features etched glass on the upper section of the double hung window while the bottom section has beveled glass.

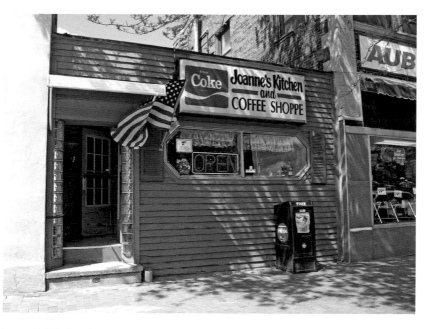

Joanne's Kitchen is another diner that does not reveal too much of its heritage from the outside. At one point in the distant past, the narrow diner was widened on site to accommodate more seating! *Photo by Larry Cultrera.*

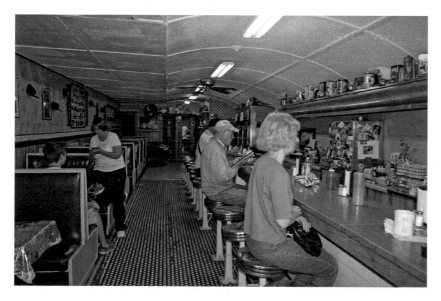

Here we can see the widened interior of Joanne's Kitchen. The barrel ceiling curves about two-thirds of the way from right to left. The booth seating on the left is basically where the alley used to be between the diner and the building next door. *Photo by Larry Cultrera.*

At one time, the place was known as Sardie's Diner. After that, it was called Bosse's Restaurant into the late 1970s. It has been owned and operated by Ron Cote since 1980, and a good portion of the clientele is made up of local customers who have been coming to this old diner for decades. Some of the waitstaff have been there for decades as well. In particular, waitress Sue Edwards has been working there for thirty years and counting. This is a no-frills diner with basic comfort food.

Breakfast is the only meal at this diner, no lunch or dinner. The diner is open Monday through Friday from 6:30 a.m. to 11:00 a.m. On Saturdays, the hours are 6:00 a.m. to 12:00 p.m. and on Sundays, 7:00 a.m. to 12:00 p.m.

HOPE'S HOLLYWOOD DINER, 127 PLAISTOW ROAD (ROUTE 125), PLAISTOW, NEW HAMPSHIRE

1952 Mountain View Diner

Hope's Hollywood Diner is the current identity of a diner that has operated under quite a few names in the last fifty years or so. This diner was originally known as Pent's Diner and was located on Route 28 in North Reading, Massachusetts, when it was brand new. It is Mountain View Diner No. 317 and happens to be one of the smallest models the company built. It operated at the first location until 1961, when owners Jim and Hope Pentoliros moved it to Plaistow. The reason for the move was a decrease in business after I-93 bypassed Route 28, taking a huge portion of north- and southbound traffic from the old road. It was reopened as Hope's Diner after it got to Plaistow and operated under that name into the 1970s. I do recall the diner looking all original circa 1971–72, when I started frequenting the area, but sometime in the mid- to late 1970s, its exterior was altered with all the stainless steel exterior skin being removed and covered with some type of siding (either wooden or vinyl). All the other stainless steel (trim and panels) by the windows was painted over. By the time I first photographed the diner in Plaistow in the early 1980s, it was being run as the Plaistownian Diner. Later still, it had the name Route 125 Diner, which remained into the early 1990s. For seventeen years, starting in 1992, Kevin Barden gave the diner its longest run as Eggie's Diner until he moved the business to a new location in nearby Atkinson in 2010. Since then, the diner has had short runs under different operators.

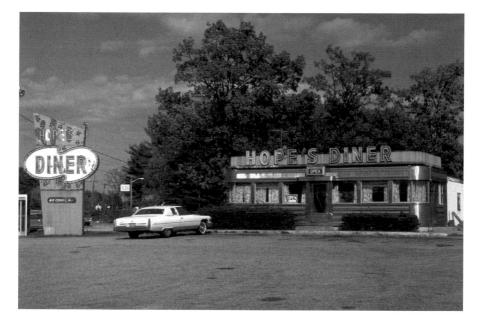

This photo from 1974 shows Hope's Diner with the original exterior of stainless steel and red stripes. It also had some nice old neon signs on the diner as well as at the side of the road. *Photo courtesy of Kellie & Richard J.S. Gutman.*

In November 2010, the diner became Diner 317 under the new partnership of John Woods, his cousin Chris Woods and Justin Behling. The trio embarked on a much-needed sprucing up of the building, which included completely gutting and then installing a new kitchen. In the diner proper, they insisted on keeping any original details that remained. There were some changes, such as the installation of new lighting and custom-made tables with benches. Unfortunately, this turned into a short run when the diner closed again in March 2011. I believe there were mitigating circumstances that may have led to the closing, such as an ongoing road construction project on Route 125 near the diner coupled with the economic recession. Within a few months, there was news that the diner was being reopened as Betty's Diner. When Anthony Raia opened the diner on June 25, 2011, it had a slight name change to Betty-Ann's Diner. The different name was due to the objections of another restaurant, Betty's Kitchen in North Hampton, New Hampshire. Betty's Kitchen apparently felt that there would be a conflict of interest if the diner in Plaistow (over thirty miles away) used the Betty's Diner name. The diner closed about a month later when Perry and Larry Pentoliros, owners of the diner and property, had

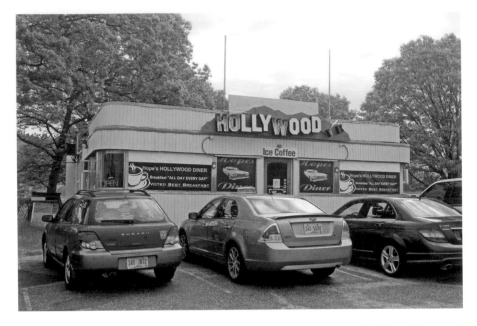

Not too long after the photo on page 63 was taken, the diner was stripped of the stainless steel exterior and covered in wood paneling. This paneling has been painted a variety of colors over the years, almost as many colors as name changes. *Photo by Larry Cultrera.*

issues with Raia and they decided to take over the operation, reopening it as Hope's Diner again. The Pentoliros brothers were quoted as saying that they wanted to get the diner open and start making some money as soon as possible. Prior to this point, neither of them had actually worked in the diner business, but their father ran the diner for many years. Renamed for their mother, Hope, the Pentoliroses said it's important for them to keep the diner going to keep their mother's legacy alive.

Early in 2014, the operation of the diner was taken over by Jim Silva, who added "Hollywood" to the name. Since taking over the business, Silva has started doing some renovation to the exterior. He told me during a visit on Memorial Day that because the diner is missing its stainless steel exterior, he wants to do a retro theme on the outside. In my humble opinion, I would have left what was still there alone. Yes, it is not original as far as the exterior façade is concerned, but it still had all the original windows. These new changes are just bringing the diner further away from looking like the classic diner that it was—oh well, it is not my call. After the exterior renovations are complete, Silva wants to try opening the diner 24/7. It looks like things are going in the right direction, as the place was very busy when I stopped in.

In fact, on our more recent visit, I had a longer conversation with Silva and also had breakfast. He gave me the distinct impression that he is here for the long haul and knows this business well.

Hope's Hollywood Diner serves breakfast and lunch and the operating hours are currently 6:00 a.m. to 2:00 p.m., seven days a week, but as I mentioned earlier, these could change.

3

Transplanted Diners

S ince the early 1960s, the entire New England region with the exception of Connecticut has had very few new, factory-built diners delivered. I can count a little less than a dozen new diners coming into Massachusetts from 1960 to the present. Rhode Island and Maine only have one example each in that time frame, and Vermont has none to my knowledge. New Hampshire has two examples of new diners delivered since 1960: Lindy's Diner of Keene (1964) and the Remember When Diner of Rochester (2001), which is currently being used as a Mexican restaurant. All the New England states have lost a fair amount of diners within the last five decades, including the Granite State. The diner scene in New Hampshire has a unique distinction in that since the end of the 1970s, there has actually been a decent increase in the amount of transplanted diners that had previous lives somewhere else, more so than any of the other states in the region. The biggest reason for this, in my opinion, is because of the resurgence in popularity that came about from the late 1970s and early 1980s with numerous newspaper and magazine articles that were spawned by the publishing of books by John Baeder (*Diners*, 1978), Richard J.S. Gutman, Elliott Kaufman and David Slovic (*American Diner*, 1979) as well as Allyson Bellink and Donald Kaplan (*Diners of the Northeast*, 1980). This publicity, along with newly formed organizations like the Society for Commercial Archeology, was bringing attention not only to diners but also to other roadside relics and attractions that were starting to disappear from the commercial landscape. Baby boomers like myself were becoming increasingly aware of this phenomenon and were starting

to document what was left, which helped bring diners to the attention of other people. Chief among these people were budding entrepreneurs and restaurant and hospitality professionals who were looking for the next big trend in the casual restaurant scene. Some of these people became nostalgic for old diners and started actively looking for prime examples to move and reuse, while others were, in fact, just looking to continue to serve food and become their own boss, operating in a classic diner environment.

MT. PISGAH DINER, 118 MAIN STREET, WINCHESTER, NEW HAMPSHIRE

1941 Worcester Lunch Car

The Mt. Pisgah Diner, Worcester Lunch Car No. 769, can be classified as possibly the earliest of the transplanted diners in New Hampshire during the period of time from the late 1970s up to the present. This diner had spent its earlier life operating in the city of Gardner, Massachusetts, where the Worcester Lunch Car Company delivered it on March 26, 1941. Owned and operated by Billie Viefeld at 240 Main Street as Billie's Diner for many years, it was later known as A&L Super Sub in the late 1970s, and my good friend David Hebb managed to get a couple of photographs of it in 1978. Around 1979, it was moved into a salvage yard for storage in the nearby town of Templeton, where it stayed for at least three years before being purchased by Richard and Phyllis Pratt, who had the diner transported to its current location in Winchester, where it was opened for business by early 1983. Taking its new name from Mount Pisgah (in nearby Pisgah State Park), the Pratts operated the diner for three years and then sold it to Charles and Judith Gilman. The Gilmans ran it successfully for the next eight years until selling to the current owner, Joni Otto, in May 1994.

Although the exterior painted metal panels are now replaced by wooden panels and trim, the place still looks like a typical barrel-roofed diner and seems to be a nice fit for the neat little downtown area it inhabits. The diner retains the original stained-glass sections on the double-hung windows and exudes a homey atmosphere, inside and out. Upon entering the diner, one can see that a lot of the original features are still intact. The ceiling, hood and other woodwork have been painted, and the original wooden booths have been replaced with more modern versions. The porcelain and steel–

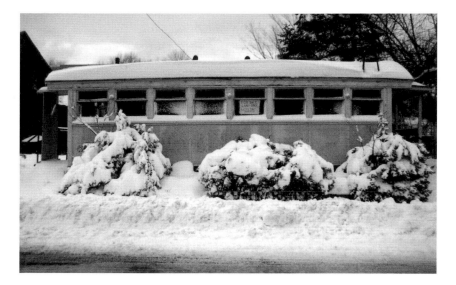

Worcester Lunch Car No. 769, the former Billie's Diner, was operated as A&L Super Sub before closing at its original location in Gardner, Massachusetts. Here it is closed and for sale around Christmas 1978. *Photo courtesy of David Hebb.*

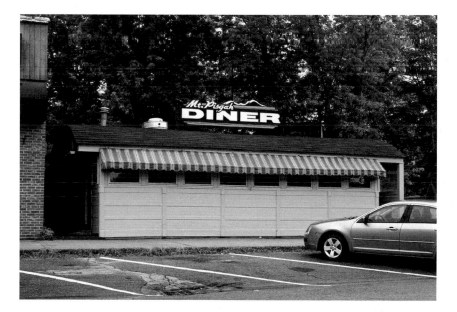

After being placed into storage for about three years, the diner was moved to Winchester, New Hampshire, to become the Mt. Pisgah Diner. Coincidentally, the green color the diner is currently painted almost perfectly mimics the color it had just before it moved out of Gardner. *Photo by Larry Cultrera.*

covered wall panels, refrigerator and back bar cabinetry are pretty much all there. The counter and stools, as well as the ceramic tile floor, are also intact, although the original black "Caf-O-Lite" counter top is now covered in a newer plastic laminate of light blue. Cooking at this diner is still done behind the counter as well as in an auxiliary kitchen in the attached building.

The customer base is primarily made up of locals, but the diner also benefits from its location on Routes 10 and 119 to cater to the transient travelers and scenic road-trippers passing through the area as well. If you are an occasional or first-time customer, you will be welcomed into the diner, which certainly seems to be the local meeting spot where all the regular customers know one another. Owner Joni Otto and her staff are extremely cordial, and the meals are wallet-friendly.

The Mt. Pisgah Diner serves breakfast and lunch. The menu is fairly extensive with many of the typical breakfast options. The lunch menu features a selection of club sandwiches, tuna melts, hamburger melts, quesadilla wraps and steak and cheese wraps. The Mt. Pisgah Diner features hand-cut French fries while all soups are homemade, and there are daily specials Monday through Friday. All pies and desserts are homemade as well.

The Mt. Pisgah Diner is open Monday through Friday from 6:00 a.m. to 3:00 p.m. and on Saturdays from 6:00 a.m. to 11:00 a.m. (for breakfast only). The diner is closed on Sundays.

TILT'N DINER, 61 LACONIA ROAD, TILTON, NEW HAMPSHIRE

1950 Jerry O'Mahony Diner

This is the third location for the diner currently operating as the Tilt'n Diner. It was originally built in 1950 by the Jerry O'Mahony Company (Diner No. 2179-50) as the new flagship of the chain of Monarch Diners based in Waltham, Massachusetts. The chain was started by the DeCola brothers in 1940 and included a number of diners in the Bay State as well as the Granite State. This diner replaced the first incarnation of the Monarch Diner for its location on Main Street in Waltham, which was a 1940 vintage Worcester Lunch Car that went on to its next life as the Owl Diner of Lowell, where it still operates to this day. The second Monarch stayed in Waltham until circa 1970, when it was moved to Salisbury, Massachusetts, where it operated

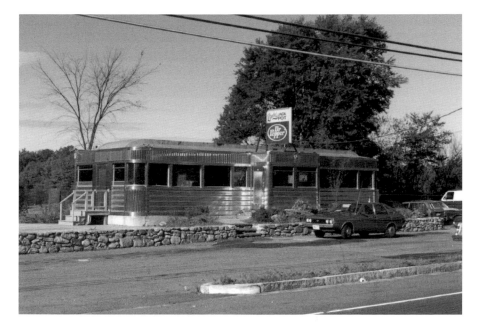

The Tilt'n Diner operated as the Monarch Diner in Waltham from 1950 to 1970. From 1970 until 1978, the diner operated at its second location on U.S. Route 1 in Salisbury, Massachusetts. When this photo was shot in 1981, the diner was trading as Linda's Jackpot Diner at that second location. Within a year or two it was renamed the Lafayette Diner and stayed under that name until it moved to New Hampshire. *Photo by Larry Cultrera.*

again as the Monarch as well as later names like Linda's Jackpot Diner and the Lafayette Diner.

The diner had closed in Salisbury by 1987 and was moved off site to storage for a short time, just off I-95. It was at this point that Alex Ray of Ashland, New Hampshire, came along and purchased the stainless steel diner. Ray is the owner of the wildly successful Common Man family of restaurants in the Granite State. He was looking for another opportunity to expand his company with a slightly modern take on the diner concept. Ray moved the former Monarch Diner from Salisbury to another temporary storage yard in Concord, New Hampshire, circa 1988 with plans of setting it up at a location in the capital city. Ray already owned some property there that housed a closed restaurant—a former Howard Johnson's, which Ray had purchased in 1987. Ray had hoped to attach the diner to the front of the HoJo's building, but the plans for the project were not approved by the city. Eventually, Ray rehabbed the HoJo's to become Al's Capitol City Diner and was fairly successful with this 1950s-themed diner until he replaced it with

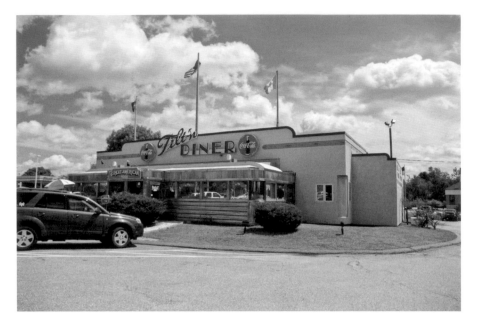

Today the former Monarch Diner is basically the front of the much larger Tilt'n Diner that comes under the umbrella of the Common Man family of restaurants. *Photo by Larry Cultrera.*

the current Common Man Restaurant. So the old Monarch Diner remained in storage until 1992, when a new location was secured on Route 3 at exit 20 off Interstate 93, in part of the former parking lot on the Pike Industries property in Tilton.

A large edifice was built to house the majority of the seating for the new restaurant as well as the kitchen, storage and restrooms. The diner was placed on the front of this addition facing the main road. When one pulls up to park at the diner, the first inclination would be to enter through the front door, but in this case, the diner's front door is not used. The main entrance is on the left side of the addition, just behind the diner. Once the patron has entered, one can either sit in the dining room or take a right and walk into the diner from an existing access door on the diner's back wall. To further integrate the diner with the main restaurant, most of its back wall was removed, although the back bar equipment is still in place. So if a customer is sitting at the counter in the diner, he or she can see out into the dining room as well as the kitchen, which is over to the right side of the dining room.

All-day breakfast, lunch and dinner are served at the Tilt'n Diner, and the hours of operation are 6:00 a.m. to 9:00 p.m. Sunday through Thursday

and until 10:00 p.m. on Friday and Saturday. The menu here is primarily the same as the Route 104 Diner in New Hampton as well as the Airport Diner in Manchester. The Common Man Restaurants are in the process of expanding again with two other on-site diners to be opened late in 2014 or early 2015 at the Hooksett Service areas off I-93, north and south.

MISS WAKEFIELD DINER, 7 WINDY HOLLOW ROAD, WAKEFIELD, NEW HAMPSHIRE

1949 Jerry O'Mahony Diner

Still another recent addition to the Granite State diner scene is the Miss Wakefield Diner. Located in the village of Sanbornville in the town of Wakefield, it is highly visible, situated at a long curve on busy Route 16. This diner is a 1949 vintage Jerry O'Mahony Company stainless steel diner that spent the first forty years of its life in the Albany, New York, area. When I first came upon it in the early 1980s, it was located on U.S. Routes 9 and 20 in the East Greenbush/Rensselaer area, operating as Pat and Bob's Diner. Other than a structure built over the roof of the diner marrying it to the kitchen addition and a large wooden-framed entryway on the front, it looked to be pretty original. The original owners were Patsy, John and Robert Carpinello, according to historian Michael Engle in his self-published book *Diners of the Capitol District*. The diner also had a previous name of Pat and John's Diner at the same location.

By the mid-1980s, the diner was closed and awaiting its next life. That came in November 1991, when Wakefield, New Hampshire, residents Richard and Sarah Benner purchased the closed diner and had it transported to a spot adjacent to their home at the end of Windy Hollow Road for restoration. While they were restoring it, they had the piece of property they owned at the corner of Route 16 and Windy Hollow Road prepared for the eventual operating location of the diner. This was a rather large undertaking, as a pretty good-sized hill on the corner was excavated to accommodate the diner and attached buildings as well as the parking lot on the property. This took the better part of a year, but the diner finally reopened as the Miss Wakefield in early 1993. The Benners operated the diner until selling the whole kit and caboodle (including their residence around the corner) to Scott and Grace Bramer on April 24, 1998.

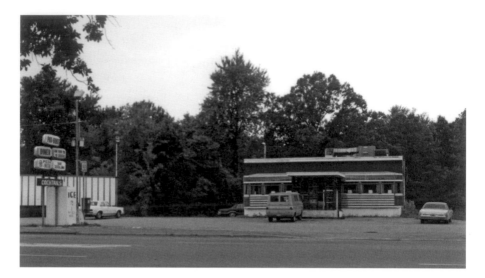

The Miss Wakefield Diner was originally Pat & Bob's Diner located directly on Routes 9 and 20 in East Greenbush just south of Albany, New York. This photo shows the diner before it closed in the early to mid-1980s. *Photo by Larry Cultrera.*

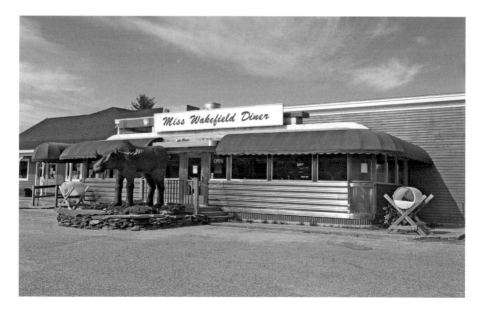

The Miss Wakefield Diner today with Gracie's Country store just to the left in this photo. A lot of people are familiar with this diner as it is on a very busy north–south route in the eastern part of the Granite State that accesses destination areas from the seacoast region in the south to Lake Ossipee and North Conway and the White Mountains to the north. *Photo by Larry Cultrera.*

The Bramers eventually put an addition on the left side of the kitchen building for Gracie's Country Store. This is used as an adjunct to the food service provided at the diner. Bramer says they get the busiest from May to October while things are quite a bit slower during the late fall and through the winter months. The Miss Wakefield serves a typical diner menu without any pretense or surprises for breakfast and lunch. The operating hours are generally Monday through Thursday from 7:00 a.m. to 2:00 p.m. and Friday through Sunday from 6:00 a.m. to 4:00 p.m.

PLAIN JANE'S DINER, 897 OLD ROUTE 25, RUMNEY, NEW HAMPSHIRE

1954 Jerry O'Mahony Diner

Another Granite State diner that came out of Upstate New York is Plain Jane's Diner of Rumney, New Hampshire. A late model Jerry O'Mahony Company diner in largely original condition, it had been closed for many years at the intersection of Routes 9 and 9H in the town of Livingston, just outside Hudson, New York. Formerly known as the Bell's Pond Diner, the place was intact but abandoned when I first photographed and documented it on October 2, 1982, and it was anybody's guess if the diner would ever be opened again. Fast-forward to 1990, Bob and Gloria Merrill were searching for a classic stainless steel diner. The Merrills were attempting to recapture a little of their youth and thought a 1950s diner would be just the ticket for their next business venture. They had first looked at the former Seagull Diner of Kittery, Maine, which was available around that time, but that was snatched away by John Keith, who, during that period, was an active diner broker/restorer. So the Merrills then came across the old Bell's Pond Diner and decided that this would be the likely candidate for their diner rescue project!

They moved the diner to Rumney, New Hampshire, just outside Plymouth, fairly close to the tourist attraction known as the Polar Caves. They spent some time restoring the diner and building an addition for a kitchen, restrooms and storage. The Merrills reopened it as Glory Jean's Diner in 1991 and ran it successfully for the next three years before selling the business to Ed and Charlotte Kimball. The Kimballs ran the diner for the next few years before they closed it in 1999. The diner stayed dormant for two years, according to Randy Garbin's book *Diners of New England*, before Jane and

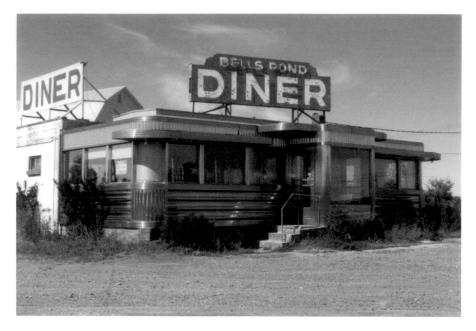

The Bell's Pond Diner in Livingston, New York, was closed for years. A very late model Jerry O'Mahony diner, it was in pretty original condition even though it was not used for quite a while. The diner was moved to Rumney in 1991 by Bob and Gloria Merrill. *Circa 1982, photo by Larry Cultrera.*

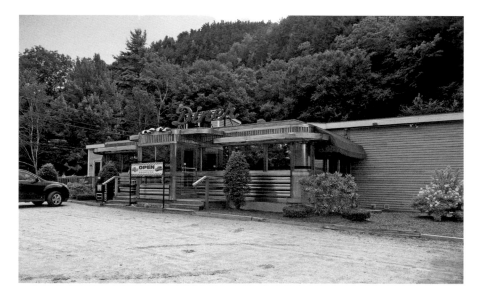

Originally opened here in 1992 as Glory Jean's Diner, this place has been known as Plain Jane's Diner since 2001. *Photo by Larry Cultrera.*

Steve Greene came into the picture. It was the Greenes who changed the name to Plain Jane's Diner. By April 1, 2004, the diner was taken over by the current owner, Jeff Day, who has obviously done something right, as his over ten years of longevity can attest to. Jeff Day had plenty of experience under his belt having been a corporate chef for Alex Ray's Common Man family of restaurants. I met Jeff in the summer of 2013 while I was on a little excursion to shoot new photographs of some Granite State diners in anticipation of writing this book. We stopped by on a sunny afternoon and had some good food as well as good conversation. Jeff is a hands-on owner who seems to be the proverbial "chief cook and bottle washer" doing pretty much everything that needs to be done. From menu selection and cooking to building maintenance, he does it.

In mid-2009, the recently closed Bobby's Girl Diner on Route 104 in New Hampton became available. There was an auction of the building and property coming up, and Jeff got a call from his old business associate Alex Ray. Ray asked him if he wanted to be partners in a new business venture that entailed reopening the diner to be jointly operated by both of them. So in October 2009, the newly christened Route 104 Diner opened for business. Jeff Day's association with Ray and the Route 104 Diner ended amicably around April 2013, with Day concentrating on exclusively operating Plain Jane's Diner again.

Plain Jane's Diner serves breakfast, lunch and dinner and is open seven days a week from 6:00 a.m. to 8:00 p.m.

ROUTE 104 DINER, 752 NEW HAMPSHIRE ROUTE 104, NEW HAMPTON, NEW HAMPSHIRE

1957 Worcester Lunch Car

The Route 104 Diner has an interesting history that took it on a series of moves since it was new in 1957. It was originally called Lloyd's Diner and was the last production diner to come out of the late Worcester Lunch Car Company factory. Designated WLC No. 850, Lloyd's Diner was delivered on May 15, 1957, to its first operating location at 2760 Hartford Avenue (U.S. Route 6) in Johnston, Rhode Island. Owned by Lloyd Hopkins, it closed there in 1988. From Johnston, the diner went on a little odyssey that finally had it delivered to its current home.

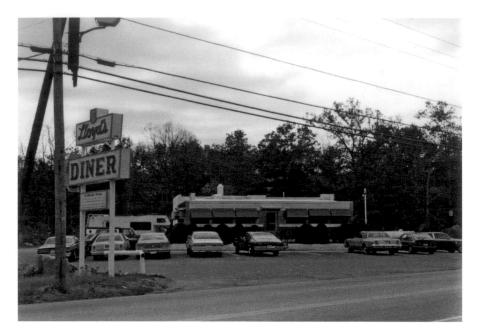

Lloyd's Diner, Worcester Lunch Car No. 850 was the last diner off the Worcester assembly line in 1957. Here it is in 1981 at its original location in Johnston, Rhode Island, where it lasted until 1988. It was moved to Massachusetts and was used again for two or three years in Weymouth before it took another trip to a storage location in Bridgehampton, New York, on Long Island. It came to New Hampton, New Hampshire, in 1994. *Photo by Larry Cultrera.*

The first place it landed after Rhode Island was a location in Weymouth, Massachusetts, where it was attached to the front of a dance club called Sh-Boom's. After a brief time, Sh-Boom's closed, and it morphed into a different nightclub. The diner remained on site but was somewhat disguised. This entity did not last long either, and the diner was again moved in 1991, when the diner was sold to John Keith, who was brokering diners for a couple years. (For more on Mr. Keith see the Leo's Diner and Streamliner Diner sections of Chapter 5.) Keith's plan was to sell it to the Fat Boys Diner chain in England and had the diner stored at O.B. Hill Trucking and Rigging Company's yard in Natick, Massachusetts. The deal with Fat Boy's Diners did not pan out, and the diner was ultimately sold to Alexis Stewart, daughter of Martha Stewart. Ms. Stewart had the diner transported to Bridgehampton, New York, on Long Island, where she hoped to get approval to set it up as the Delish Diner. Her plans ran into a roadblock when the town fathers dragged their feet and eventually nixed the concept. It did not fit into their

vision for the town apparently. The diner ended up sitting in a field for two years, during which time, at some point, it actually got broken into and two stools on the left end of the counter were physically removed.

In 1994, Bob and Gloria Merrill decided to get back into the diner business. In 1990, the Merrill's had successfully moved a diner to Rumney, New Hampshire. They set up and operated the former Bell's Pond Diner, (long closed in upstate New York) as Glory Jean's Diner (now Plain Jane's Diner). They sold that diner after a couple of years to operate a different business but within a year or so decided they missed running the diner and started looking for another one. They finally settled on WLC No. 850 and purchased it from Alexis Stewart. The Merrills found a piece of property to set up their new diner on Route 104 in New Hampton, New Hampshire, ironically within walking distance of my in-laws Sarah and Don Sorenson's home. Not long after the diner was installed on its new foundation and the attached buildings were being built, I stopped in to check the progress. Bob and Gloria were actually there so I introduced myself to them and reminded them we had met a few years before when they were setting up their previous diner in Rumney. In speaking with them they told me that the diner was missing two stools and how they were trying to find replacements. They had talked to someone who assured them that the stools in the diner were not original equipment. In fact most Worcester Lunch Cars sported different stools so I could see how someone would think they were not originals as these were more streamlined than the normal stools.

I looked at the stools and told the Merrills that I believed they were, in fact, original to the diner. They asked me how I knew, and I told them that I happened to have two stools out of the former Georgetown Diner (WLC No. 849), which had also been brokered by John Keith. Both of those diners were in the Worcester factory around the same period and that style of stools apparently were what the company was using at the very end of production. Keith had replaced all the stools in the Georgetown due to the fact that it had been modified when it was operated as Randy's Roast Beef to serve a limited menu and the owners removed all but three or four stools at the counter. I had obtained the stools two or three years earlier when Keith had traded them to me for another artifact I had in my possession. They were being stored at my mother's house, and I had no plans to use them myself. So I offered them to the Merrills for a small amount of money, and they were extremely happy to acquire them to complete the diner, which they opened shortly thereafter.

The Merrills operated this diner for quite a few years before selling it to the Elliard family in 2002. The Elliards operated the diner until late June

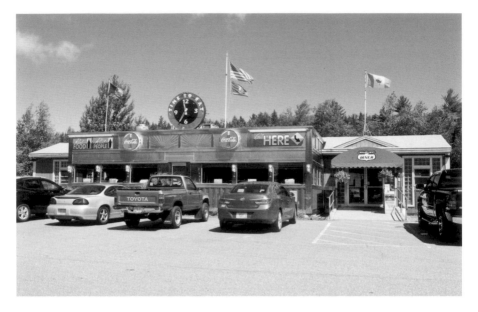

The diner operated as Bobby's Girl Diner for a number of years before becoming the Route 104 Diner in 2009. It received the new stainless steel façade with the large clock above the windows at that time. *Photo by Larry Cultrera.*

2009, when they decided to close the business. In a June 24, 2009 newspaper article, it was reported that after buying the diner, the Elliards' plan was to develop the remaining part of the property adjacent to the diner. But due to recent changes in zoning, they were no longer able to develop the close-to-twelve acres that the diner sits on. Because further development was hindered, they could no longer afford to operate the business. So Bobby's Girl Diner was auctioned off on July 14, 2009, and was renamed the Route 104 Diner.

Reopened on October 8, 2009, after some cleaning and updating, the Route 104 Diner was at that time actually being run as a joint venture between Jeff Day of Plain Jane's Diner in Rumney, New Hampshire, and Alex Ray's Common Man family of restaurants based in the Granite State. Besides the affiliation to Plain Jane's Diner, the Route 104 Diner joined two other diners that Ray's Common Man Restaurants operates: the Tilt'n Diner of Tilton, New Hampshire, and the Airport Diner of Manchester, New Hampshire. I eventually got up to New Hampton to check out the Route 104 Diner in February 2010 to see what had changed. The first thing I noticed was that the canvas awnings that had been installed when it became Bobby's Girl

were all removed. One other change made actually took me by surprise—Day and Ray had extended the parapet above the windows. Normally, I am not too much of a fan of changes to the exterior of a classic diner, but in this case, this particular modification was done very well and does not detract visually from the overall aesthetic of the original design. According to Jeff Day, as of April 2013, his affiliation with Plain Jane's Diner ended, and the Route 104 Diner is wholly owned and operated by the Common Man Restaurants. The menu is identical to both the Tilt'n Diner and the Airport Diner. The Route 104 Diner is open daily at 7:00 a.m., serving breakfast (all day), lunch and dinner. Sunday through Thursday the diner is open until 8:00 p.m. and Friday and Saturday until 9:00 p.m.

RILEY BROS. DINER AT SILVER LAKE RAILROAD, 1381 VILLAGE ROAD, MADISON, NEW HAMPSHIRE

1941 Sterling Diner

Riley Bros. Diner spent the first sixty-five years of its life in the city of Lynn, Massachusetts. Originally owned by the namesake Riley brothers, it was known far and wide for its chicken potpies. After the Riley brothers, the diner had operated under a number of names over the ensuing years. I can recall driving by it on Boston Street in Lynn back in the 1970s when it had a sign with the name "Buster's" covering the Riley Bros. name that is baked into the porcelain steel panels. Later into the 1980s, it had names like the Boston Street Diner, as well as Serino's Diner, before it stopped serving food.

By the mid- to late 1980s, the interior appointments were entirely removed and the building became the Balloon Boutique, a store that sold floral arrangements and balloons. By 2006, that business had moved to a different location, and the diner building was closed and empty. The site was slated for development and the diner in danger of demolition. It was offered to anyone who could foot the bill for moving the diner out, and this is when Neil Underwood of the Silver Lake Railroad came into the picture. Once the diner was moved to Madison, New Hampshire, Neil Underwood and his associate, carpenter Peter Wing, embarked on putting an interior back into the building. But before they could do this, the whole back wall of the diner needed to be

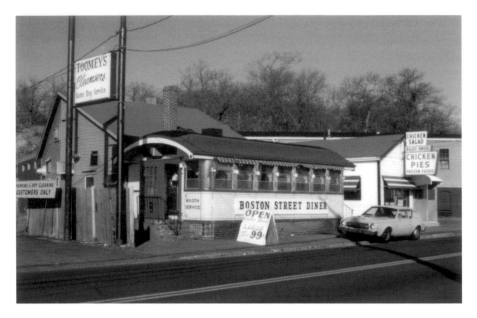

Originally in Lynn, Massachusetts, here is Riley Bros. Diner in a 1980 photo when it was called the Boston Street Diner. It was used as a balloon and florist store from the mid-1980s until it closed circa 2006. *Photo by Larry Cultrera.*

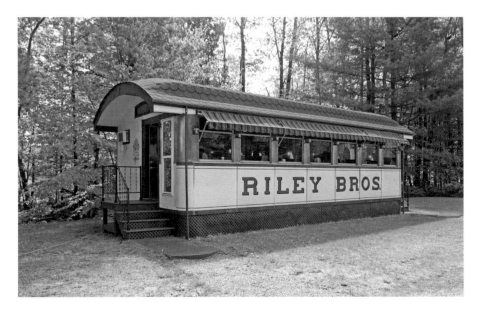

Neil Underwood spent some time, sweat, equity and money installing a new interior consisting of a counter, stools and booths in the old Riley Brothers Diner. It is currently used as a static display, and visitors are welcome to eat a picnic lunch inside. *Photo by Larry Cultrera.*

completely rebuilt, as it basically was not there. After this was accomplished, they rehabbed the interior by installing new interior walls of natural wood panels and a linoleum tile floor as well as a counter, stools and booths.

After the refurbishment was complete, this diner was open as an ice cream stand for two operating seasons. Unfortunately, this ice cream operation was too involved and ultimately too expensive for an all-volunteer organization to operate feasibly. So the decision was made to make this a static display museum piece; however, guests of the railroad are welcome to sit down, enjoy the atmosphere complete with rock-and-roll and enjoy their picnic lunch. Self-serve treats are available for purchase in the railroad depot.

ROGER'S REDLINER DINER, 2454 LAFAYETTE ROAD, PORTSMOUTH, NEW HAMPSHIRE

1950 JERRY O'MAHONY DINER

A long disused diner I personally never thought would serve a meal ever again has become the newest transplanted diner in the Granite State. I am happy to say that Roger's Redliner Diner opened for business on February 21, 2014, in Portsmouth. Technically, you could say that this diner has come back home to New Hampshire as it had previously operated from 1950 to 1968 as the Monarch Diner of Dover, New Hampshire, part of an enterprise started by the DeCola brothers based in Waltham, Massachusetts. The chain consisted of quite a few diners that traded under the Monarch name including several Massachusetts locations: the aforementioned Waltham (now the Tilt'n Diner in Tilton, New Hampshire), Saugus (now Martha's Coventry Diner, Coventry, Vermont), Arlington, Billerica, Littleton and Woburn (all gone). The other Monarch Diners were located in Dover (now Roger's Redliner Diner) and Milford, New Hampshire (now gone). Other diners in this chain had traded under names such as the Bedford Diner of Bedford, Massachusetts, as well as one (or both) of the Paradise Diners of Lowell, Massachusetts. I first became aware of the Monarch Diners by collecting diner postcards in the early 1980s. I obtained one for the Monarch Diner of Waltham, and the image depicted that diner but also mentioned the Dover, New Hampshire, location. As far as I knew, the Dover location was defunct by that time, and I figured it did not exist anymore. I later learned

that both diners were built in 1950 by the Jerry O'Mahony Company and were very similar—pretty much the same size, though the configuration on the interior was slightly different. The Monarch in Dover was serial number 2163-50 while the Monarch in Waltham was serial number 2179-50. Serial numbers for Jerry O'Mahony diners (when found) will always be four digits then a hyphen with the last two digits representing the production year. It seems the DeColas leased or eventually sold their places to other people to run. The operators known to be associated with the Monarch in Dover were Fred and Irene Jewell.

So getting back to the Dover Monarch/Roger's Redliner, by the time I started documenting diners in the early 1980s, the only diner left in Dover to my knowledge was Stoney's Diner (see the Sunny Day Diner in the "Longtime Favorites" chapter). It was not until March 12, 1989, on a surprise visit to an old friend who was living in Acton, Maine, that I found out the fate of the Monarch Diner from Dover. When Steve Repucci and I showed up early on that Sunday afternoon, we talked for a while with my friend Rick Clauson and his wife, Dawn. After a period of time, Rick said, "C'mon let's take a ride. I have something to show you." So we proceeded to drive heading east away from his house on a side road that was used by locals as a short cut into nearby Sanford. As we rounded a curve on Twombley Road, this large stainless steel diner sitting up on timbers came into view. We stopped and got out to check out the place, and I snapped a few photos. The owner of the property, Phyllis Neal, who lived in the house adjacent to where the diner was being stored, was there, and I approached her to ask about the diner. She proceeded to tell me that the diner had originally been located in Dover. I asked if it had been the Monarch Diner. She answered in the affirmative, and she invited us to take a look at the interior, which was accessed by a ladder.

We discovered that, aside from its being used for storage in conjunction with her greenhouse business, the diner was surprisingly intact. Mrs. Neal told us that her husband had purchased the diner in 1968 after it had closed in Dover and moved it to downtown North Berwick. I have since found out through information gathered by Will Anderson for his 1995 self-published book, *More Good Old Maine*, that although they had originally thought about using the diner as a store to sell flowers, the Neals changed their minds and decided to set it up and lease the diner to a lady named Lois Griffin, who operated it as Lois' Diner until late 1973. The diner remained closed and vacant at the North Berwick location until the Neal family relocated it to their property in Sanford at 604 Twombley Road in 1986, where they began

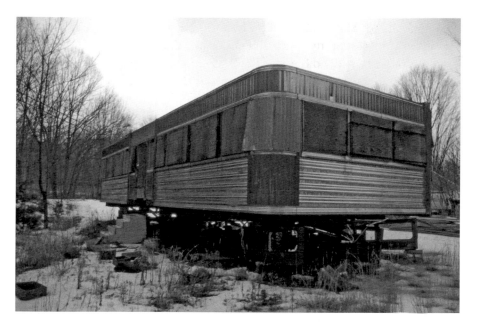

This former Monarch Diner originally operated in Dover, New Hampshire, from 1950 to 1968. It was moved to North Berwick, Maine, and operated as Lois' Diner until 1972. It remained closed at that location until it was relocated in 1986 to Twombley Road in Sanford, where I found it in 1989. *Photo by Larry Cultrera.*

using it for storage. Even though I had been documenting diners with my photographs since 1980 and made quite a few friends who had been doing the same thing even longer, I found the fact interesting that none of us who followed diners were aware of this diner being in North Berwick. The only reason it may have been under the "diner radar" is the fact that it had been closed there since 1973.

A number of years later, Dave Pritchard convinced Mrs. Neal to sell the diner to him. Pritchard already had the former Fasano's Diner (aka the Olympian Diner) from South Braintree, Massachusetts, along with the Miss Newport Diner from Newport, Vermont, and the Englewood Diner of Dorchester, Massachusetts, being stored at his Aran Trading, Ltd., a container, truck and trailer sales yard, in Salisbury, Massachusetts. This would have been around the summer of 2004. In fact, I was traveling back from seeing the newly installed Blast from the Past Diner in Waterboro, Maine, on July 8, 2004, along Maine Route 4 (if I remember correctly), when I was surprised to see the diner again, this time at a different location. I did not stop to photograph it or even take note as to the location (for which I am now kicking myself). But by my best guess, it

was sitting on a trailer at the side of the road near the intersection of Morrills Mill Road and Route 4. Obviously, it was being moved somewhere, as it turned out, to Salisbury and Dave Pritchard's yard. Probably within a year or so of that sighting, I again ran across it at Aran Trading, Ltd., and photographed it there.

Fast-forward to December 2012, I was contacted by my friend Beth Lennon who lives in Phoenixville, Pennsylvania, with her husband, Cliff Hillis. Beth is a kindred spirit originally from the metro Boston area and is a photographer of the American roadside and a collector of kitsch; needless to say, she loves all things retro, including diners. She also writes the very popular blog Retroroadmap.com, which is extremely entertaining to read. She mentioned to me in an e-mail that she had recently become acquainted with newfound friends Daryl McGann and Roger Elkus, who are, respectively, the general manager and owner of a chain of bakery/cafés known as Me and Ollie's in the Portsmouth, New Hampshire area. Daryl got in touch with Beth via e-mail in early November 2012 after seeing her blog and mentioned how they had bought an old diner to eventually reopen. They invited her to meet them the next time she was in the area and talk about the diner, which conveniently turned out to be not too long after. Beth and Cliff were planning on being in Massachusetts for Thanksgiving and made a special trip to meet Daryl and Roger at one of the Me and Ollie's Cafés in Portsmouth. During that meeting, Beth mentioned that they would be back in the area at Christmas, and Roger invited them to come see the diner during that return trip. Beth knew that I would be interested and suggested that my wife, Denise, and I meet her and Cliff on their way and join them to meet with Daryl and Roger to see the diner. When she described to me which diner they had bought, I agreed to go—it was the old Monarch Diner sitting in storage in Salisbury.

On the agreed-upon date, we got together with Beth and Cliff at nearby Kane's Donuts in Saugus and drove up to Salisbury from there. After meeting Daryl and Roger, we went into the storage yard. They described their search for a used diner and how it had led to Dave Pritchard. Pritchard had previously sold the Miss Newport Diner to be used as the new Miss Mendon Diner in Mendon, Massachusetts. So when we got into the storage yard I expected to see three diners still sitting there. It turns out only two were left—the Monarch and the Olympian. I asked them if they knew what had happened to the Englewood Diner, and they told me it was sold to New Balance Footwear in Brighton, Massachusetts. This was a surprise to me. So while we were there, we did climb inside to check the diner out, and it was pretty much in the same condition as when I had been inside back in 1989.

A few short months later, McGann and Elkus secured a new home for the diner and had it moved in June 2013 to Southgate Shopping Plaza right next door to Water Country Water Park. The diner anchors a new wing of the reconfigured plaza just behind the branch of the First Colebrook Bank, which has frontage on U.S. Route 1. I visited the diner on the second day it was open for business, and I was happy to see the place looking so good for a diner that had lain dormant for so long. It was a fantastic resurrection in my opinion. Roger told me that his intention was not to make the diner look new but instead look more like the worn but polished antique that it actually is. A new entryway vestibule was created, as the original one from the factory did not survive after it was stored in Sanford. The new one is slightly larger than the original and has a door on the front façade rather than a door on each of the sidewalls. Steve Harwin of Diversified Diners (Cleveland, Ohio) provided some materials to help in the restoration, including stainless steel–covered doors for the exterior. All new glass was installed in the original window openings. The exterior stainless steel panels were removed, cleaned up and reinstalled. The cleaning up of these consisted of removing some decoration that was put on to take the place of the original red enameled stripes. New red stripes were applied after the panels were reinstalled. McGann and Elkus retained Jutras Signs and Flags out of Bedford, New Hampshire, to create a beautiful new neon sign to be mounted on the roof, finishing off the exterior nicely.

Work on the interior of the diner consisted of a major cleanup and some updating. The electrical and plumbing were brought up to code, along with a required sprinkler system and handicap accessibility. The stools were all removed to facilitate being stripped, cleaned and refinished before being reinstalled. McGann and Elkus had tried to get the stool bases and other pieces rechromed, but they found that there are few chrome plating companies these days and the ones that do exist are tooled for industrial high production. They were told that this project was too small. Some would do custom work on a small scale, like for motorcycles, but this would have been too costly and basically priced them right out of the market. They found a company called Powder Coat Alternatives located in nearby Greenland, New Hampshire, which knew exactly the right material to use and could do all the sandblasting and finish work in the shop. As Daryl McGann said, "Nothing beats chrome but the powder coat has a good look." They had all the stools, table legs and chairs done in this fashion. Behind the counter, some newer equipment was brought in and was incorporated with whatever original fixtures were left to help

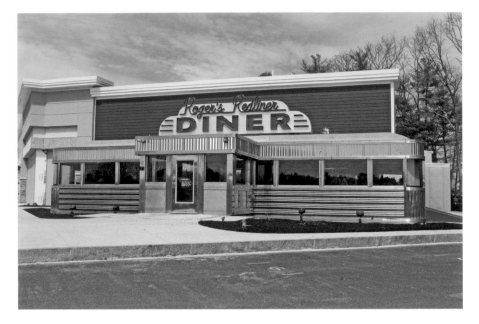

The former Monarch/Lois' Diner was resurrected and reopened as Roger's Redliner Diner in early 2014 after spending most of its life closed and in storage. *Photo by Larry Cultrera.*

retrofit a reconfigured back bar. There were some original booths left in the diner—the row along the sidewall near the entrance to the restrooms is original. In fact, they found the serial number 2163 written in chalk on the frame (which verified the number stamped into the stainless steel frame at the front door). The booths along the front wall on the left end are mostly new—there was some material left from the original. The rest of the booth frames, other than some minor repair, are all original. Steve Turner of Rye, New Hampshire, did the upholstery work, and both he and Al Stillman rebuilt the frames. The terrazzo floor was brought back from the very dull and lifeless finish it had to a brighter, glossier one.

Roger's Redliner Diner serves breakfast (all day), lunch and dinner seven days a week. The diner is open Monday through Thursday from 7:00 a.m. to 9:00 p.m. and Friday and Saturday from 7:00 a.m. to 10:00 p.m. On Sundays it is open from 7:00 a.m. to 9:00 p.m.

HOMETOWN DINER, ROUTES 119 AND 202, RINDGE, NEW HAMPSHIRE

1949 Silk City Diner

The Hometown Diner is the realization of a dream that local business owner Tim Halliday had for a few years. Halliday, who owns and operates 202 Truck and Equipment in Rindge, also owned a piece of property at the intersection of U.S. Route 202 and state Route 119 down the street. His dream was to bring a vintage diner to town and set it up for business at that highly visible location. I first became aware of Halliday's plan via an e-mail from Evie Goodspeed on July 10, 2012. Evie works for Tim Halliday, and she told me in this e-mail that they had been looking to purchase a vintage classic diner for the past year and had not had much luck in finding one. Evie went on to say that she basically wanted to know if I was aware of any diners in the Northeast that might be for sale and added that they had the ability to move a diner themselves.

I got back to Evie and suggested she get in touch with Dave Pritchard of Salisbury, Massachusetts, who had two or three diners possibly for sale. She immediately answered that they had known about Dave and already checked out what diners he had in storage, ultimately deciding those particular diners did not meet their requirements. I also told Evie about Steve Harwin, the leading diner restorer and broker currently active in the country. Harwin's company, Diversified Diners, has been responsible for saving and rehabbing many classic diners over the last twenty years or so. Evie told me that they had actually been in contact with Steve, but communication was moving very slowly. In fact, Steve told them he did not have a diner at that point in time available for sale. I gave them one or two suggestions of dormant diners that were for sale, which unfortunately did not work out either. Their luck changed not too long after this when Steve Harwin called to let them know of the availability of the closed Hometown Diner.

The Hometown Diner was operated for many years as the Silver Diner, located in London, Kentucky. This was a 1949 Silk City Diner built by the Paterson Vehicle Company of Paterson, New Jersey (No. 4931). The Silver Diner was a little worse for wear when it closed at the end of 2005. Steve Harwin had heard about the closed diner and that it was available. He went down to Kentucky to inspect the diner and described what he found: "It had a front entrance and a side entrance but the vestibule was missing. There were two doors leading out the back of the diner, a center door for the access

The Silver Diner of London, Kentucky, sits closed in 2005. Covered over with T-111 wooden paneling, only little glimpses of its original exterior show through here in this photo. *Photo courtesy of Steve Harwin & Diversified Diners.*

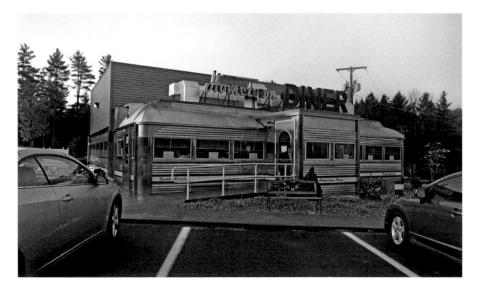

The Silver Diner became the Hometown Diner in 2010 and operated in Ottawa, Ohio, for a couple of years before becoming available again for resale. Here it is reborn as the Hometown Diner in Rindge, New Hampshire, in October 2013. *Photo by Larry Cultrera.*

to an annex kitchen and the door on the right side leading into additional seating area and restrooms."

Steve also told me in a phone conversation that 90 percent of the original stainless steel façade had been stripped off at some point in the past when the T-111 wooden paneling was added to the façade. Another roof had been built that incorporated the diner with an attached building. Only the stainless steel trim around the windows and the corner pieces were left intact from the diner's original façade. When Harwin decided to obtain the diner, he got a crew together to disconnect it from the adjacent structure and remove it for transport back to Cleveland.

As Steve Harwin said, "The diner was configured by the factory to seat fifty-two, but we modified it slightly to allow for more spacious seating and ADA accessibility. It measures approximately forty feet long by fifteen feet wide. It took eight months to restore the diner for the new owner Matthias Kaplanow."

Steve told me this restoration was a challenge for him. Even though he had restored quite a few Silk City Diners, all of those previous diners had porcelain-enameled steel panels and not the stainless steel panels that these slightly newer models had. To assist in the restoration, he traveled to Meriden, Connecticut, and took numerous photos of the former New Palace Diner now operating as Cassidy's Diner, which was a similar model. The photos helped him replicate the stainless steel panels that he then had to figure out how to install properly. The restoration of this was completed in 2010, and Steve was justifiably proud of the outcome. The diner was then moved to Ottawa, Ohio, where Kaplanow, a German national, had some property. He opened the establishment as the Hometown Diner. Unfortunately, Matt Kaplanow was under the mistaken impression that he could run the diner from his home in Germany. This arrangement did not work out, and the diner was closed in 2012.

Fast-forward to mid-May 2013, when I read online that a new diner was coming to Rindge, New Hampshire. I started reading the piece, and then the light bulb went off—I know who this is and what diner they are buying. I immediately got on the phone and talked with Evie. I said to her (without identifying myself), I see you people got the diner you were looking for! She laughed, and I then identified myself. She said they had mentioned my name within the last few days and were going to let me know about the news, but I beat them to it. The diner was moved from Ohio to New Hampshire shortly after I spoke with Evie in early June and was quickly installed on a foundation at its new location. During a later conversation, Halliday told me

that he hoped to have the diner operating by September. His plans did not include operating the diner himself, but he was in negotiations with interested people who were very experienced in running a food establishment.

Halliday eventually obtained the services of Bonnie Rosengrant, who was able to put together a seasoned crew to help with the operation of the diner. Well, the proposed September opening came and went, but the diner finally opened on October 4. By all accounts, the place has been swamped with a large amount of customers since the opening. The Hometown Diner's operating hours are Monday and Wednesday through Friday from 5:30 a.m. to 2:00 p.m., Saturday and Sunday from 5:30 a.m. to 4:00 p.m. and closed on Tuesdays. Starting on May 29, 2014, the diner will open for dinners Thursday through Saturday until 8:00 p.m. There will be blackboard specials along with an expanded dinner menu. The diner is also planning some special events on Sundays during the summer months.

4

On-site and Homemade Diners

There are many restaurants that serve breakfast and lunch (and sometimes dinner) in the New England region that can come under the classification of having a diner-like ambience without being situated in a classic pre-fab diner. These places more often than not are local gathering spots that have, in some instances, been around for decades. New Hampshire has quite a few of these on site/homemade places that sometimes even have "diner" in their names. Some are housed in stand-alone buildings while others are located in commercial storefronts and strip malls. They can look homey like George's Diner in Meredith or closer to factory-built diners with a stainless-steel-and-enamel-striped exterior like Mary Ann's Diner in Derry or Joey's Diner in Amherst.

RED ARROW DINER, 61 LOWELL STREET, MANCHESTER, NEW HAMPSHIRE

On-Site

Manchester's Red Arrow Diner is the only remnant of a once flourishing chain of diners operating in southern New Hampshire, although as of 2008, another location was opened in Milford. According to the diner's history, at one time there were five Red Arrow Diners operating within the Manchester city limits, and I personally have a postcard of one in Nashua dating to the

The Red Arrow Diner in Manchester has roots that go back to horse-drawn lunch wagon days. Once part of a chain of at least five diners in southern New Hampshire, this was the sole remaining one until current owner Carol Sheehan started branching out in 2008. *Photo by Larry Cultrera.*

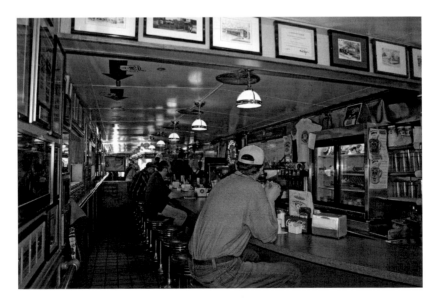

Even though the Red Arrow Diner is housed in a building that was built on site, it has the layout and ambience of any factory-built diner. The menu certainly screams DINER and the fact that it is open 24/7 means you cannot go wrong at any time of day. *Photo by Larry Cultrera.*

1930s, which also may have been part of this regional group of diners. The current Red Arrow Diner on Lowell Street is rumored to have started out as a lunch wagon, but there is certainly no evidence of this now in the existing structure, which by all appearances is a brick building built on site. An old matchbook cover refers to the chain as the Red Arrow Lunch System, which listed a restaurant at 1195 Elm Street and lunchrooms at 61 Lowell Street (the current location), 37 Lake Avenue and 16–18 West Merrimack Street. There was also a Red Arrow Inn at 1199 Elm Street, which appears to have been a hotel that featured "modern rooms."

The Red Arrow Diner first opened its doors in Manchester, New Hampshire, back in 1922. The original founder was David Lamontagne. At one point, there were a total of five Red Arrow locations throughout the city. The name Levi Letendre also goes hand in hand with the Red Arrow. Levi worked for the Red Arrow for many years and eventually bought it from the Lamontagnes. He ran it successfully until his retirement in 1978. After Letendre, there were a few more owners until it closed circa 1987, when, for the first time since 1922, the Red Arrow Diner was for sale and vacant. That is when Carol Lawrence purchased it and brought the diner back to life. Taking a page from past history, Lawrence is expanding the brand. In 2008, she purchased the Milford Diner and reopened it as the second location of the Red Arrow Diner. Another Red Arrow Diner is slated to open by the end of the year in 2014, at a location off I-93 at exit 5 in Londonderry.

The Red Arrow Diner is open twenty-four hours a day, seven days a week, and the whole menu is served, regardless of the time of day. The breakfast menu is chock-full with all the normal items one would expect. One of my favorite things about this menu is the fact that they not only offer pan-fried potatoes but also hash browns—always a plus in my mind. (Roger's Redliner Diner offers these also). At the Red Arrow Diner, breakfast, lunch and dinner are served twenty-four hours a day, seven days a week!

GEORGE'S DINER, 10 PLYMOUTH STREET, MEREDITH, NEW HAMPSHIRE

On-Site

George's Diner in Meredith, New Hampshire, is a local landmark that anyone who lives or vacations in the Lakes Region seems to know. Owned

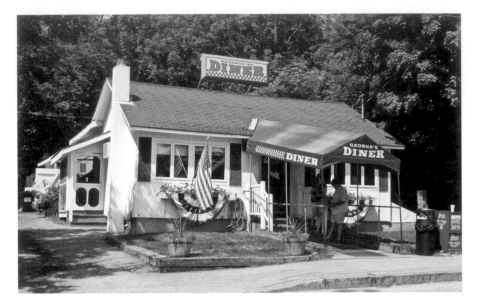

On the outside, George's Diner in Meredith certainly looks like the tourist cabin it once was. But this place is the local gathering spot for good friends and camaraderie with a reputation for good food and service, and it almost never closes. *Photo by Larry Cultrera.*

The interior of George's Diner is very homey, and if you are there at the same time as owner Roger Rist, you can be sure to be greeted like you were an old friend, even if you are visiting for the first time. *Photo by Larry Cultrera.*

and operated by Roger Rist and his wife, Robin, since May 1991, it is a popular diner that gets pretty well jammed with customers, but more so in the spring and summer when the population here balloons in this picturesque vacation spot on Lake Winnipesaukee. In fact, this on-site built diner is in the Cape Cod style and looks like it could be someone's house.

In fact, from what I have been told, the building at one time was a duplex cabin originally located in the Weirs Beach area a few miles away, prior to being moved to the current location. Since moving, the building has housed various restaurants including one called Musher's Den, which was a local roadhouse serving hamburgers and beer. From the late 1970s into the early 1980s, Mary Caron had the place for a few years and ran it as Caron's Diner prior to moving the business and name to the Turning Point Restaurant in Hillsborough (currently the Hillsborough Diner) in 1983. After Caron left the diner in Meredith, it was bought by George Danforth and became George's Diner. Through Mr. Danforth's efforts, the business, along with its reputation for good food as well as being the local gathering spot, grew—so much so that when the Rists purchased the place, they decided to keep the name. I had been hearing good things about this little place for many years but had not visited it until recently. In the warm-weather months, it is so busy, the overflow extends out to the screened-in patio on the right side of the building.

George's Diner serves breakfast, lunch and dinner and features home-baked bread as well as huge homemade muffins. Breakfast is served every day until 2:00 p.m. George's Diner is open all year, seven days a week, from 6:00 a.m. to 8:00 p.m.

MARY ANN'S DINER, 29 EAST BROADWAY, DERRY, NEW HAMPSHIRE

On-Site/Storefront

Derry was once home to John and Bill's Diner, which was located at the corner of Crystal Avenue and Broadway close to where CVS and Dunkin' Donuts are today. This was a barrel-roofed diner of 1920s vintage that is fondly remembered to this day by people of a certain age. Just down the street from this same corner on East Broadway is a much newer place that has quickly become a local favorite in a fairly short amount of time.

Mary Ann's Diner, started by William and Mary Ann Andreoli in 1989, is currently operated by their children. Some diner purists might scoff at Mary Ann's, saying it isn't a "real" diner because of its on-site pedigree, situated as it is in an existing retail block. But in my opinion, this is a textbook example of how to create a diner out of an existing building, using enameled panels, stainless steel trim and some neon on the exterior—not to mention using loads of Formica laminate, stainless steel trim and glass block as well as ceramic floor and wall tile on the interior to create the illusion of a modern 1950s retro diner.

They are a little bit heavy on the 1950s kitsch, which I usually do not go for, but somehow at Mary Ann's, it does not seem to detract—probably because of all the major advantages this diner has going for it. These include great service and food at reasonable prices, which definitely seals the deal. It seems no matter what time of day that I visit this diner, it is extremely busy. When it opened in 1989, the exterior did not have a lot of embellishments on the front façade and virtually none on the back. The front just had some quilted stainless steel around the doorframe, along with the signage above the windows. Below the two front windows, there was a red-and-white checkerboard pattern. The interior at first was a reasonable facsimile of what a diner should look like, as some of the elements it has now were already in place.

My earliest photos of Mary Ann's revealed that this was the way it looked when I first visited the diner for a meal in 2002. On a later visit, probably in 2004, I noticed some differences both inside and out. I was sitting at the counter and realized that they had someone come in and add a bit of authenticity to the interior. Chief among these changes that I noticed was a "cove" ceiling above the back bar that was not there on my previous visit. I asked someone (it may have actually been Mary Ann Andreoli) about the changes, as well as who might have done them, and she told me that a company from New Jersey was responsible for the work. I then asked if it was the same company who did the work transforming a stick-built building in Amherst, New Hampshire, into the Timeless Diner (now Joey's Diner), and she said yes, it was. I had witnessed that company working on the Timeless Diner and knew that it had the needed expertise in diner renovation to pull it off. Some details that I saw in the Timeless Diner were evident to me on my second visit to Mary Ann's. In researching for this book, one of my goals was to find out the name of the company that did the renovations, as I had never heard it. I just knew it was not one of the existing diner manufacturers.

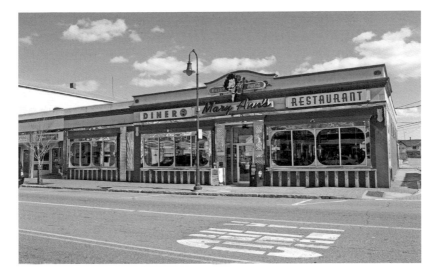

Mary Ann's Diner still has the dimensions and lines of the downtown store block it inhabits, but the blue enamel vertical stripes with the mirror-finish stainless steel trim applied to the exterior along with the signage have helped transform an ordinary building into a retro 1950s diner. *Photo by Larry Cultrera.*

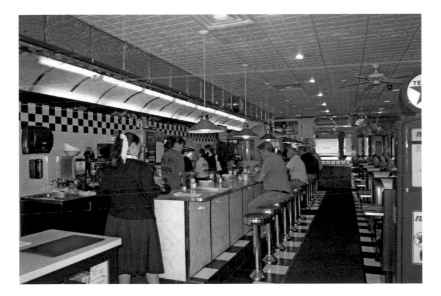

The interior of Mary Ann's Diner is filled with memorabilia and '50s paraphernalia, which could be distracting but somehow it works here. A lot of the work on the exterior as well as the interior of Mary Ann's was done by a contractor out of Newark, New Jersey, that was known for its expertise in diner renovations. *Photo by Larry Cultrera.*

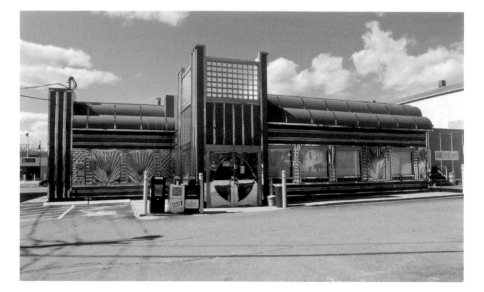

This is the only photo I shot for this book to show the back of a diner. The rear wall of Mary Ann's Diner was pretty much just the back of a brick building that faced the parking lot prior to Designer Diners of New Jersey working their magic by transforming it into a modern diner façade. *Photo by Larry Cultrera.*

I was not having too much luck until I contacted Sharon M. Jensen, the executive secretary of the town of Derry's DPW Department. I asked if the information that I was looking for might be in a building permit. She told me that more than likely it would be. A few days later, she got back to me with the permit, which was issued on October 23, 2003, for an addition and remodel of existing diner. The contractor listed on the permit was in fact Designer Diners, Inc., of Newark, New Jersey. The addition mentioned in the permit included a total transformation of the back façade of the building facing the parking lot. The contractor installed stainless steel with red-and-blue enameled panels along with a large two-story entrance that featured the same materials with some glass block added. They also made a small dining room to the right of the entry. Capping the top of the back walls on either side of the entryway was a waterfall type "roof topper" all in red with stainless trim molding. The front façade also received more stainless steel trim as well as blue vertically fluted panels under the windows, completing the diner look the place has today. The diner now seats 275 people and always seems to be serving at or near capacity on any given Saturday or Sunday morning when I've stopped in. In November 2013, the Andreolis

opened a second Mary Ann's Diner in a strip mall at 4 Cobbetts Pond Road in Windham, New Hampshire. The Windham location is smaller (it only seats 90), but by all reports, it seems to be doing well.

Mary Ann's Diner serves breakfast seven days a week (all day) while lunch is served Monday through Friday only (lunch is not served on holidays). There are several beers available as well as mimosas during brunch. Operating hours are Monday through Saturday from 6:00 a.m. to 2:00 p.m. Sunday hours are 7:00 a.m. to 2:00 p.m.

JOEY'S DINER, 1 CRAFTSMAN LANE AND ROUTE 101A, AMHERST, NEW HAMPSHIRE

On-Site

Back in 2001, Steve Repucci and I had made a trip up to the Milford Diner in Milford, New Hampshire (now the Milford Red Arrow), one Saturday for breakfast. We were talking about diners with some of the regular customers and heard about a new diner being built about six miles down the street on Route 101A in Amherst, New Hampshire. Being extremely curious, we

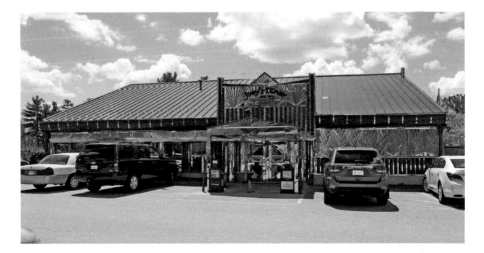

Joey's Diner was the first place in New Hampshire to receive a complete makeover by Designer Diners of Newark, New Jersey. It is a textbook example on how to make an existing building look like an ultra-modern diner. Joey's originally opened as the Timeless Diner in 2002. *Photo by Larry Cultrera.*

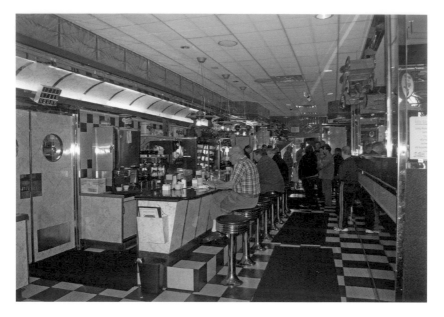

Here is an interior view of Joey's Diner. You are looking toward the entrance, showing the counter area with stools. This place is huge and has seating for 220 patrons as well as a small function room that accommodates seating for 30. *Photo by Larry Cultrera.*

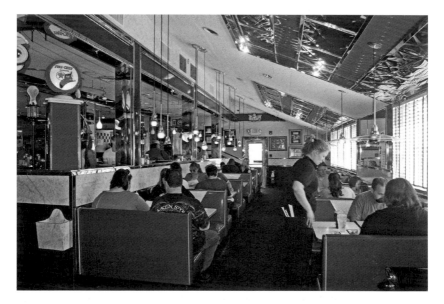

Another interior view of Joey's standing in pretty much the same spot as the previous view. Turning to the right, you are looking at two of the dining areas, getting a sense of how big this place is. *Photo by Larry Cultrera.*

detoured in that direction on the way home to check this report out. We were surprised to see an existing building being transformed into a mirror-finish stainless steel and red enameled modern diner called the Timeless Diner. We were told that this building had previously housed other eating establishments that had opened and closed over the last few years. A New Jersey–based contractor well versed in diner renovation was doing the on-site work of transforming the building. As I found out in my recent research for this book, the contractor was in fact Designer Diners, Inc., of Newark, New Jersey, which went on to do work at Mary Ann's Diner in Derry.

The diner was at that time owned by the Georgoulakos family, who opened it on April 22, 2002. The restaurant could accommodate 220 people and also featured a small function room that could seat 30. As I mentioned, I was very impressed with the red enamel and mirror-finish stainless steel exterior, as well as the fantastic interior décor to this ultra-modern diner. For an on-site diner, the workmanship rivaled anything from longtime manufacturers like Kullman and DeRaffele. The Timeless Diner operated for two years before the Georgoulakos family sold the business to the current owner, Joey Medeiros, who changed the name to Joey's Diner.

Joey's Diner is open seven days a week, serving breakfast, lunch and dinner. Operating hours are 7:00 a.m. to 8:00 p.m. Breakfast is served all day while lunch and dinner are served only after 11:00 a.m

AIRPORT DINER, 2280 BROWN AVENUE, MANCHESTER, NEW HAMPSHIRE

On-Site

The Airport Diner in Manchester is part of the Common Man family of restaurants started by Alex Ray. It joins other diners that Mr. Ray owns, including the Tilt'n Diner and the Route 104 Diner. The difference is that those other two diners are classic factory-built diners, and the Airport Diner was built in 2005 from the ground up to look and feel like a classic diner. The Airport Diner is actually part of the Holiday Inn Express hotel conveniently located near the Manchester-Boston Regional Airport right off the Brown Avenue exit of I-293. In a recent conversation with Alex Ray, he told me that he and Common Man family vice-president Diane Downing felt that building a diner like this one from the ground up was highly preferable to

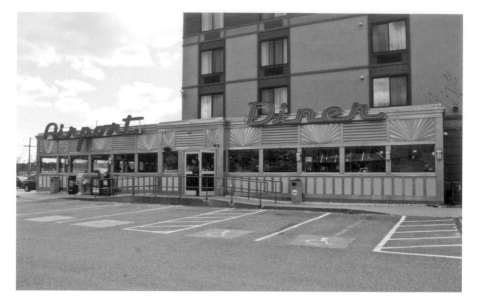

The Airport Diner in Manchester is attached to the Holiday Inn Express. The third diner run as part of the Common Man family of restaurants, this one was built from the ground up. This place has the look and feel of a real diner. *Photo by Larry Cultrera.*

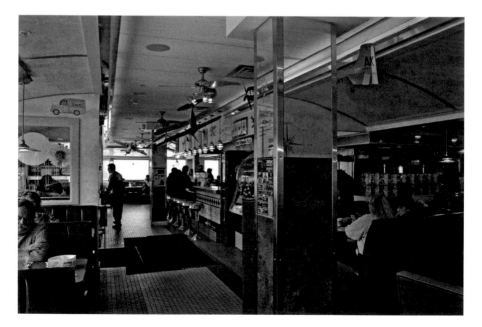

The interior of the Airport Diner is well appointed. It features a lot of Formica surfaces, ceramic tile and stainless steel molding along with a fair amount of neon to pull off the look. *Photo by Larry Cultrera.*

buying an older diner, moving it to a new location and bringing it up to code. So from his point of view, this diner has become the basic prototype for the style of retro diner he envisioned. In fact there are plans in the works currently to expand his restaurant holdings by building two more on-site diners at the Hooksett Service areas off I-93, north and south. These diners are slated to be opened late in 2014 or early 2015.

The Airport Diner is filled with historic photographs of Manchester Airport and vintage planes and paintings that contribute and enhance the diner's aeronautical theme. These photos and artifacts were selected by Diane in partnership with the New Hampshire Aviation Historical Society. The menu at the Airport Diner is the same one used at the Tilt'n Diner and the Route 104 Diner. Breakfast is served all day. The diner is conveniently open from 5:00 a.m. to 12:00 p.m. seven days a week!

5

Former New Hampshire Diners Living Another Life Elsewhere

O ver the last thirty-some-odd years, a half dozen classic diners have been moved from their original home (or last operating location) in New Hampshire to other locations in various parts of the country. I will talk about five of these in this chapter. Two have actually been put back into service while one is in private hands. The other two are in known storage locations and may or may not ever come back into service. Harold's Diner, which was once in Rochester, New Hampshire, is the last of the six diners. I did not cover it in this edition because it is currently among the missing, although it is believed to still be in private hands, reportedly in Barrington.

STREAMLINER DINER, AKA NEWPORT DINER, 66 MAIN STREET, NEWPORT, NEW HAMPSHIRE

1939 Worcester Lunch Car

Delivered to Allen Street in Hanover, New Hampshire, on October 19, 1939, the aptly named Streamliner Diner was designated Worcester Lunch Car No. 751. It remained in Hanover until 1957, when it was moved to Newport to take the place of Billy's Diner. In fact, Billy's was turned sideways and attached to the back of the Streamliner to be used as an auxiliary kitchen.

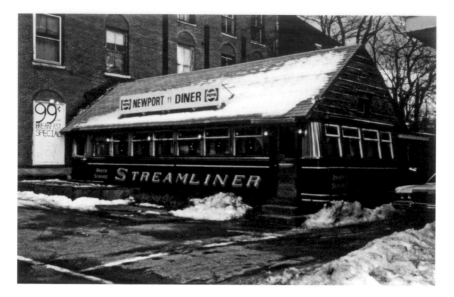

The Streamliner, aka the Newport Diner, last operated as the Newport Pretty Good Diner in the mid-1980s. This diner was first located in Hanover, New Hampshire, and was moved to Newport in 1957. It acquired the peaked roof sometime in the late 1970s. *Photo by Larry Cultrera, 1980s.*

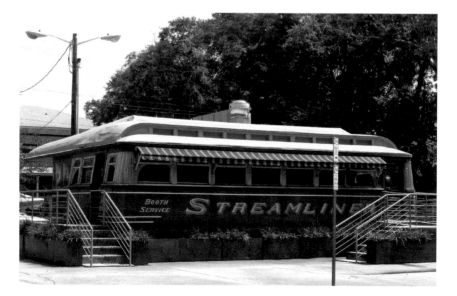

The Streamliner closed in the late 1980s and eventually made it to Savannah, Georgia, where it was restored and reopened by the Savannah College of Art & Design. *Photo courtesy of Kellie & Richard J.S. Gutman.*

It was operating as the Newport Diner in the early 1980s, and toward the mid-1980s, it was trading as the Newport Pretty Good Diner right up to the time it closed (circa 1986 or '87). In March 1988, John Keith, a real estate developer living in Manchester, bought the Streamliner. That diner purchase actually led to him buying at least a half dozen more (including two other Granite State diners—see Leo's Diner section in this chapter as well as the Route 104 Diner section of Chapter 4), thus becoming a full-fledged diner broker. Keith saw the possibilities of the combination of a business investment coupled with the satisfaction of a reawakened love of diners. Keith grew up in Short Hills, New Jersey, and frequented the Summit Diner in Summit, New Jersey, as a kid. Keith's first plan was to find a likely business site in the Bedford, New Hampshire area to move the Streamliner and set it up in business again. But real estate prices proved unreasonable, so he then moved the diner to Concord, New Hampshire, where he had initial repairs made to the structure before selling it to Red Baron Antiques of Atlanta, Georgia, in August 1988. The diner was transported to Georgia, where it was eventually auctioned and immediately put up for resale by the new owners. By 1990, it was moved to Savannah, Georgia, and set on a new foundation located at 120 West Henry Street. It was purchased, restored and reopened by the Savannah College of Art and Design, serving breakfast and lunch Monday through Thursday from 8:30 a.m. to 4:30 p.m.

TONY'S DINER, U.S. ROUTE 1, RYE, NEW HAMPSHIRE

1933 Worcester Lunch Car

Tony's Diner, originally located in Salem, New Hampshire, was known as the Park Diner when it was delivered from the Worcester Lunch Car Company on June 14, 1933. Owned by Horace Mayhew, the diner was WLC No. 705. Sometime later, the diner was transported to Rye, just south of Portsmouth on U.S. Route 1. It eventually became Tony's Diner, operated by Tony Raduazo into the mid-1980s, when it closed. The owner of the property in Rye was a guy named Henry Ciborowski.

Ciborowski was also the owner of an insurance agency in Worcester, Massachusetts, and, being very familiar with Worcester Lunch Cars, decided to move the diner off the property prior to selling the parcel. He moved the

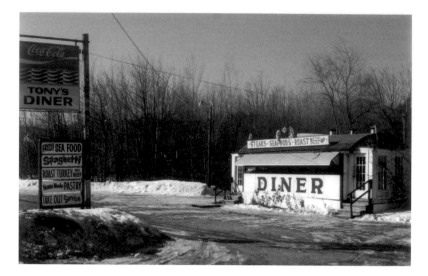

Tony's Diner (Worcester Lunch Car No. 705) operated for many years on U.S. Route 1 in Rye, New Hampshire. Originally operated in Salem, New Hampshire, as the Park Diner, it closed in Rye in the late 1980s. *Photo by Larry Cultrera.*

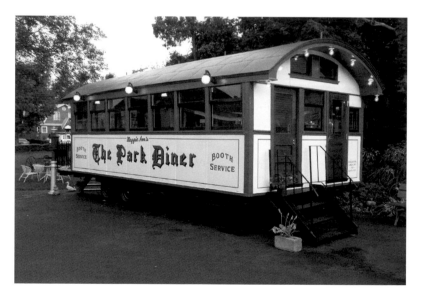

Tony's was brought back to the city of Worcester and donated to the Heritage Historical Society (now known as Preservation Worcester). They rehabbed the diner, and it was used as a tourist information booth for a while, among other things. It was damaged by a fire and eventually restored by current owner Mike O'Connor. After a lengthy restoration, O'Connor renamed it the Park Diner and is keeping it for private use. *Photo courtesy of Mike and Maggie Ann O'Connor.*

diner to Worcester and donated it to the Worcester Heritage Preservation Society (currently known as Preservation Worcester). The group raised about $30,000 to restore it, and after the diner was cleaned up and restored, it was used as a tourist information booth. In 1996, the city and Preservation Worcester decided to request proposals for use of the diner. Forum Theatre offered a plan for the use and upkeep, so Preservation Worcester allowed Worcester Lunch Car No. 705 to be used as a ticket booth, a concession stand and a changing room in its outdoor home at Cristoforo Colombo Park. After a short period of disuse, it ended up being burned in a fire caused by vandals. The city was at a loss for what to do with the derelict diner when in stepped a gentleman named Mike O'Connor, who said he would take it off the city's hands and attempt a restoration. O'Connor and his wife, Maggie Ann, moved the diner to their property and started their renovation project by gutting the inside. Then they cleaned and painted the diner, preserved anything original they could and then began their search for items to outfit the inside. O'Connor also enlisted the services of Gary Thomas to help in the restoration. Thomas, who is a knowledgeable diner historian as well as a furniture restorer by trade, did an outstanding job of replacing all the burned woodwork and back bar cabinetry in the diner over the next few years.

They searched for a marble countertop and brass hardware for the refrigerator. They were lucky to pick up an original slab of marble from behind Ralph's Chadwick Square Diner (also in Worcester). Other items they found on Craigslist or obtained at yard sales and from friends and family. They found used wooden booths for $300 online instead of having to pay $3,000 for new booths. The diner is staying in the O'Connors' yard for the immediate future. O'Connor was quoted as saying, "I'm planning on keeping it here on my property and enjoying it with our friends. It is a great place for car club meetings, etc."

LEO'S DINER, 114 SOUTH MAIN STREET, ROCHESTER, NEW HAMPSHIRE

1946 Worcester Lunch Car

Leo's Diner was a nicely kept postwar Worcester Lunch Car operated for over forty years by members of the original family who purchased the diner brand new. Designated as WLC No. 796, it was delivered to 114 Main

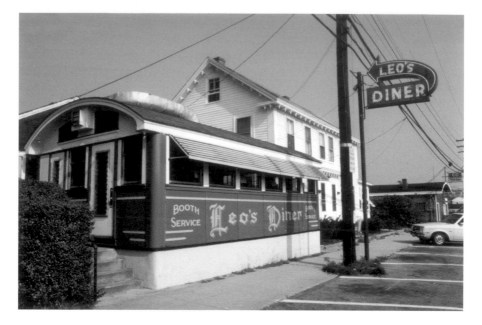

Leo's Diner was operated for many years by members of the extended Denault family at 114 Main Street in Rochester, New Hampshire. Delivered in 1946, the diner was moved out in 1988. *Photo by Larry Cultrera, 1980s.*

Street on November 14, 1946. Leo's was originally owned by Leo and Edith Denault. Leo died in 1980 at sixty-eight years of age, and Edith passed away five years later at seventy-six years of age. They had already retired years before, turning over the operation of the diner to their stepson William Clark in 1962. Clark and his wife, Lorraine, operated the diner until Clark's unexpected death in 1985.

The diner was sold at this time to a purchaser who intended to operate it as a restaurant; however, it never reopened. Around this time, John Keith was starting to purchase diners to restore and resell (for more on John Keith, see the Route 104 Diner section in Chapter 3 and the Streamliner Diner section in this chapter). Leo's Diner was Keith's second diner investment. He purchased it in 1988 and moved it in December of that year to a site visible from Interstate Route 93, just north of exit 4, near Londonderry, New Hampshire, where he erected the sign "Diners for Sale," announcing his emergence as a diner broker. Keith found a new owner for Leo's, and the diner was moved in June 1989 to Cleveland, Ohio, where its new owners followed through with their plan to place it inside a building containing their other business, South East Harley-Davidson. Reportedly one of the largest

This is a postcard showing the former Leo's Diner at its current location. In 1989, the diner was installed inside the South East Harley-Davidson dealership building in Cleveland, Ohio. It has been operating as the Harley Diner ever since. *Collection of the author.*

Harley-Davidson dealerships in the world, they cut an opening into the wall of their service department to give the building movers access to move the diner inside. Once inside, the diner was set up, and they added another room to the back of it for kitchen space. The only exterior changes to the diner entailed putting a standing-seam copper sheathing on the roof and removing the two panels that had the name "Leo's" from the front. They moved the panels that said "Diner" to the middle of the front façade and placed two plain metal panels on either side of the "Diner" panels. They painted these, matching the original blue with yellow stripe porcelain panels. They also painted Harley logos on these new panels as well as reworked the old Leo's Diner neon sign to read "Harley Diner." They opened the diner to the general public as well as their motorcycle customers, operating as a regular diner. In fact, these motorcycle dealership owners were the first to operate a diner in their store but not the last—at least two or three others have followed their lead.

LOUIS' DINER, ROUTE 3, CONCORD, NEW HAMPSHIRE

1932 Worcester Lunch Car

Louis' Diner, Worcester Lunch Car No. 708, was a sixty-foot-long deluxe monitor-roof diner built in 1933 for Herman Rich of Newburyport, Massachusetts. Originally called Rich's Annex, it was the second of two diners delivered to Mr. Rich's site on State Street in that port city. The first diner was Car No. 696, which was delivered the year prior and was called Rich's Diner. It was fairly similar to the Annex, although slightly shorter by a foot or so. When the annex was brought in, it was connected to the first diner, making for almost 120 feet of diner. The Annex was originally configured with booth and table service only while Car No. 696 had booth and counter service along with a back bar/kitchen area. It was eventually separated from No. 696 by the end of the 1930s and was reconfigured by Worcester to have a counter with stools and a small cooking area behind the new counter. After the changes were made, the diner was moved to Revere, Massachusetts, for a short time, operating near the Wonderland Dog Racing Track. By 1941, it had come to Concord at the corner of U.S. Route 3 and Airport Road. It was owned and operated by Louis Kontos as Louis' Diner

Louis' Diner was located on Route 3 in Concord, New Hampshire, for many years. The diner was moved out in the mid-1990s and has remained at various storage locations in Rhode Island ever since. *Photo by Larry Cultrera, 1980s.*

for many years. Even after the ownership changed in the 1990s, the name was retained. The diner closed circa 1999 and was moved to the first of various storage locations in Rhode Island the next year. The last report of the diner's whereabouts was in 2012. I heard from Gary Thomas that the diner was in Richmond, Virginia, where a new owner has plans to restore and reuse it.

RALPH'S PLACE, AKA ROUTE 28 BAR AND GRILL, 282 NORTH BROADWAY AND ROUTE 28, SALEM, NEW HAMPSHIRE

1940 Sterling Streamliner

Although currently dismantled and stored at an undisclosed location, this diner was/is a surviving example of an exceedingly rare Sterling Streamliner, originally named the Hesperus Diner (No. 406). It was built by the J.B.

The former Hesperus Diner of Gloucester, Massachusetts, operated for many years at two different locations in Salem, New Hampshire. It was operated as Ralph's Place for most of its time in Salem, but the last few years, it was known as the 28 Bar & Grill. It was moved to Connecticut and remains in storage at this time. *Photo by Larry Cultrera.*

Judkins Company in 1940 and operated for nineteen years at 218 Main Street in Gloucester, Massachusetts, until being replaced by a larger diner there in 1959. It joined the ranks of two other Sterling Streamliners that had operated in the Granite State over the years: the Rainbow Vets Diner of Manchester and the Yankee Flyer Diner of Nashua. According to the current owner (who wants to remain anonymous):

> *No. 406 was one of the first Sterling Streamliners ordered by an actual outside client. Sterling No. 405 and another streamliner previously built in 1939 were spec prototypes built by Judkins to promote the new design. Due to site limitations in Gloucester, No. 406 was fabricated and erected in 1940 off-site at Sterling Diner / J.B. Judkins factory in Merrimac, Massachusetts. It was then transported whole thirty-five miles south to its first operating site in Gloucester, Massachusetts, where it replaced a Ward & Dickinson–built diner. Moving an erected Sterling diner in general, and a streamliner specifically was contrary to the norm. Due*

to their absence of a steel frame and turnbuckles, most Sterlings were shipped knocked-down in four-foot-wide sections (floor, front + back wall + roof) and erected on site."

In 1959, the diner was subsequently moved from Gloucester to a location on Main Street, near the corner of South Broadway in Salem, New Hampshire. This was the first of two locations where it operated in Salem. By the late 1970s, it was owned by Ralph Spencer and operated as Ralph's Place. In 1980, Ralph moved the diner to 282 North Broadway, where he continued conducting business as Ralph's Place. He also had a pub downstairs in the diner's basement called The Office. After Ralph Spencer sold the diner to Fred Leccese in the 1990s, it became the 28 Bar and Grill until closing in January 2003. The diner sat empty for the next two years and never reopened. Sometime in 2004, the land it occupied was sold for redevelopment. Richard Pulsifer, the new owner of the property, unsuccessfully tried to give the diner to Canobie Lake Amusement Park and the Town of Salem, which did not pan out. Pulsifer, not wanting to demolish the structure, offered the diner for sale. The diner did get sold eventually and was moved to a location in North Granby, Connecticut, in July 2005, with plans to be put back into service. Those plans unfortunately fell through, and in January 2006, the diner was moved into storage, where it was subsequently disassembled. It is anyone's guess if this diner will ever get restored and opened sometime in the future.

6

Lost Diners of New Hampshire

I have been documenting diners in the Granite State with my photographs since the early 1980s. There are quite a few diners I got to photograph in those early days that have since gone to that "diner graveyard" in the sky. Some of them were already closed and soon to disappear while others may have been closed for the day at the time that I visited them to photograph. Furthermore, at least two of the diners listed below have been dismantled either for use as replacement parts in other diners or put into storage for possible future reuse in other restoration projects.

BARR'S DINER, ROUTE 106, LOUDEN, NEW HAMPSHIRE

1938 Jerry O'Mahony Diner

Barr's Diner, a late 1930s vintage Jerry O'Mahony Company Monarch model, originally operated in East Milton, Massachusetts, but was displaced when the Southeast Expressway was constructed right through East Milton Square in the late 1950s. It turned up in Louden on Route 106 next door to what had been known as Brair Motor Sport Park (now New Hampshire Motor Speedway) sometime after leaving Milton. It stopped operating as

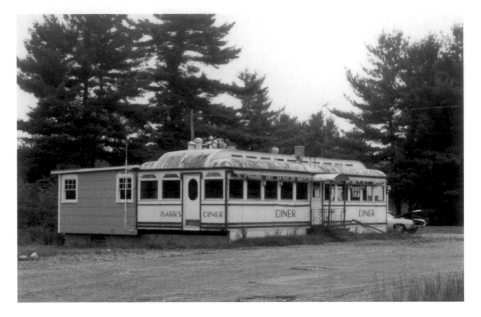

Barr's Diner in Louden on Route 106 next door to what had been known as Brair Motor Sport Park (now New Hampshire Motor Speedway). *Photo by Larry Cultrera, 1981.*

a diner prior to 1981, when I first photographed it. After being used as a security office for the racetrack for a number of years, the diner was moved out in 2008 with the hopes of being reused. Unfortunately, within the last two years, it was reported to have been demolished.

EARL'S DINER, AKA DEARBORN'S DINER, ROUTE 106, LOUDEN, NEW HAMPSHIRE

1947 Worcester Lunch Car

The last semi-streamlined model built by the Worcester Lunch Car Company was Car No. 805. It was delivered June 26, 1947, to the corner of Union Avenue and Main Street in Laconia, New Hampshire, and was operated by the Corriveau family as Earl's Diner. In 1952, the diner was bought by Bob and Ann Dearborn to become Dearborn's Diner, which continued operating until 1968. The diner was relocated from Laconia due to urban renewal, and a high-rise elderly housing project

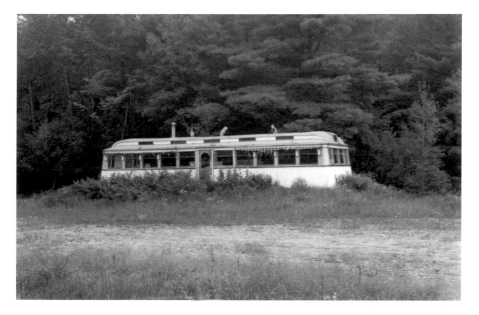

The former Earl's Diner, (aka Dearborn's Diner) on Route 106 in Louden. *Photo by Larry Cultrera, 1980s.*

called Sunrise Towers replaced it. It was moved to a spot two miles north of Barr's Diner on Route 106 in Louden. The new owners had started to set it up here in Louden but never completed the task. It stayed here, unused until the mid-1980s when the salvage rights were purchased by the Henry Ford Museum. The diner was stripped of usable parts to help restore another Worcester streamliner the museum had in its possession called Lamy's Diner. In early 1988, the derelict diner collapsed under the weight of heavy snow.

SUNSET DINER, ROUTE 125, LEE, NEW HAMPSHIRE

1920s Worcester Lunch Car

The Sunset Diner was a 1920s vintage Worcester Lunch Car located in Lee, New Hampshire, on Route 125. It had been modified sometime before I found it in 1981 with larger windows replacing the original

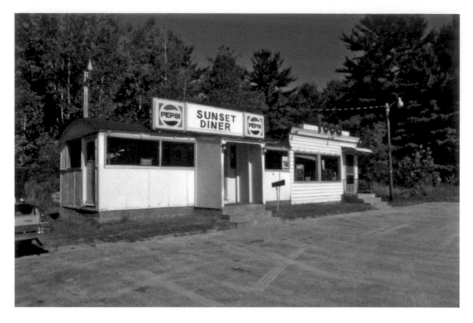

The Sunset Diner on Route 125 in Lee, New Hampshire. *Photo by Larry Cultrera, 1980s.*

factory-installed smaller ones. It also featured an added-on dining room to facilitate more seating for the narrow diner that had only counter seating. It was demolished in the mid- to late 1980s and replaced by a larger building that was built on site, closer to the road. That building was used as the new Sunset Diner for a few years but has since been utilized for different purposes.

RAINBOW VETS DINER, ROUTE 28 BYPASS, HOOKSET, NEW HAMPSHIRE

1940 Sterling Streamliner

I found the former Rainbow Vets Diner sitting in the woods, off the side of the Route 28 Bypass in Hookset, New Hampshire, in 1981. This single-ended Sterling Streamliner was the second incarnation of the Rainbow Vets Diner that once was operated by Clifford L. Robinson at 271 Elm Street in Manchester. It had replaced a 1920s vintage barrel-roof diner circa 1940.

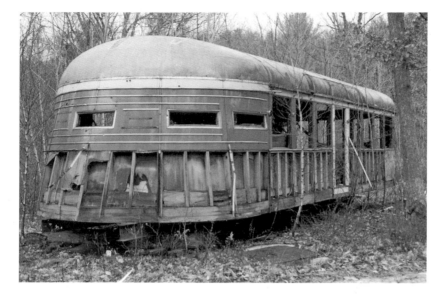

The former Rainbow Vets Diner was pretty much the ultimate abandoned diner. It sat in the woods off the side of the Route 28 Bypass in Hookset, New Hampshire. *Photo by Larry Cultrera, 1981.*

The diner was moved here after its time in Manchester (possibly in the 1960s), and I am not sure if this was placed here temporarily for a possible reuse or not. Be that as it may, the diner was completely vandalized while it sat here, stripped of pretty much everything remotely usable. It was in tough shape in 1981, when I first saw it, but I have been told by Richard J.S. Gutman that it was pretty much destroyed as early as 1974. What was left of the diner was eventually demolished by the mid-1980s. Even though this stretch of road has been getting more and more congested with new development over the last twenty years, this site is still vacant today.

LANCASTER DINER, ROUTE 3, LANCASTER, NEW HAMPSHIRE

1940s On-site Art Deco Diner

The Lancaster Diner was located in a storefront of a commercial block on Main Street (U.S. Route 3) near the corner of Canal Street in Lancaster.

The Lancaster Diner, a little over ten years before it was destroyed by fire. *Photo by Larry Cultrera, 1986.*

I give a lot of credit to the person who first opened this place, as a lot of effort went into transforming the front of the building to look like an Art Deco 1940s streamlined diner. They had custom-built porcelain-enameled steel panels made to cover the section of the building that housed the diner and attached dining room. I do not recall if I had heard about this place prior to my visit in January 1986. I was traveling north on U.S. Route 3 through town and saw this diner, but I never got to go inside as it was not open on that Saturday afternoon, but I did get a few photos of the exterior! I hear the place was as nice on the inside as it was on the outside, but I never got the chance to revisit the diner. As I understand it, Frank Savage operated the diner for many years. Savage in turn sold the diner around 1994 or '95 to Bob Bodoin, who had spent a lot of money upgrading the interior. The building housing the diner along with at least one adjacent building was unfortunately destroyed by fire on June 10, 1996. The blaze took out four Main Street businesses, including the Lancaster Diner and Lancaster Fruit and Deli. From what I read, eighteen months later, the owner of one of the destroyed buildings was charged with two counts of arson. After an unprecedented four

trials, he was found innocent in 1999. The diner has never been rebuilt, and the lot remains empty to this day.

ANDRE'S DINER, 225 LINCOLN STREET, MANCHESTER, NEW HAMPSHIRE

1920s Worcester Lunch Car

Andre's Diner was located in a heavily industrial area of Manchester. It was a 1920s vintage barrel-roofed Worcester Lunch Car that had seen better days. The business started at another location north of downtown Manchester years earlier by Andre Calin before Dorothy Close and her family took over the operation. The Closes moved the business into this diner in 1974. The business stayed here until 1992. New information on this diner has recently come to light, right after I wrote a post in my Diner

Andre's Diner of Manchester was demolished in 1992. In this circa 1984 photo, we can see that the original roof had been covered with a peaked roof. This was done because the old one was sagging, more than likely due to many heavy snowfalls over the years. *Photo by Larry Cultrera, 1984.*

Hotline blog about the publication of this book. In this post, I showed a photo of Andre's Diner and diner historian Gary Thomas commented on it. It seems in doing research for his book *Diners of the North Shore*, he had some knowledge of a diner that operated on Congress Street in Salem, Massachusetts, as the Hawthorne Diner (later renamed Pequot Diner). That diner was relocated to nearby Beverly, Massachusetts, for a short time in the late 1940s to early 1950s as the Junction Diner prior to being moved to Manchester, New Hampshire, in 1954. Gary's further research indicated a diner first showed up (in the city directories, circa 1954) at 225 Lincoln Street in Manchester and operated as Loretta's Diner, which just happens to fit the time frame for the move of the Junction Diner to New Hampshire. Between the two of us, we concluded that this was, in fact, Andre's Diner. The diner itself was demolished in the early 1990s after Close moved her business to an existing building in a strip mall that is still open at 100 Willow Street. The new Andre's Diner only serves breakfast and usually is closed before lunch.

AL'S CAPITOL CITY DINER, 25 WATER STREET (U.S. ROUTE 3), CONCORD, NEW HAMPSHIRE

Converted Howard Johnson Restaurant

Al's Capitol City Diner was Alex Ray's first attempt at running a retro diner as part of his growing Common Man restaurants. The diner was housed in a former Howard Johnson located in Concord that Ray had purchased in 1987. Ray's plans initially were to attach the former Monarch Diner/ Lafayette Diner he purchased and moved from Salisbury, Massachusetts, to the front of this building. But those plans never came to fruition, so instead, he had the HoJo's rehabbed, turning it into a real old-fashioned '50s style diner. Ray eventually opened the former Monarch in Tilton as the Tilt'n Diner in the spring of 1993. The Capital City Diner became a popular local hangout and a must-stop on every politician's tour of the state. In 2000, a decision was made to replace the Capital City Diner in Concord with a Common Man Restaurant. The old structure was torn down and a new, charming, New England home and barn was built in its place.

Al's Capitol City Diner of Concord, New Hampshire, is in a former Howard Johnson's restaurant. It operated here from 1987 until 2000, when the current Common Man Restaurant replaced it. *Photo by Larry Cultrera, 1989.*

Fueling a big part of my obsession has also been collecting diner postcards as well as photos I have come across. Old diner postcards are a tried-and-true way of seeing what was around the state in earlier times, especially of the ones that do not exist anymore. The following are a few examples that I have collected over the years.

OLD PHOTO, YANKEE FLYER DINER, NASHUA, NEW HAMPSHIRE

I purchased the photo on page 128 on eBay of the Yankee Flyer Diner, a very popular double-ended Sterling Streamliner that was located on Main Street in Nashua, New Hampshire. As I understand it, the photo was taken by an amateur photographer by the name of Yann DePierrefeu. According to what I have learned, Mr. DePierrefeu was fairly well educated and married into wealth. From what I was told, he basically was a man of leisure and gallivanted around shooting photographs of anything that interested him. I'm told he was

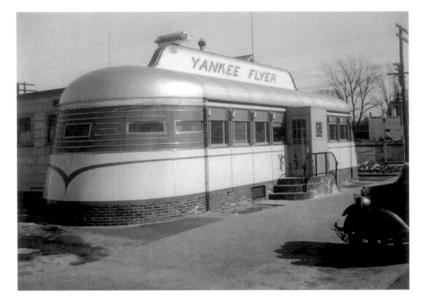

This is a photo I bought of the Yankee Flyer Diner, a longtime fixture located on Main Street in Nashua, New Hampshire. *Collection of the author.*

especially fond of railroad depots and documented quite a few of them with his photographs. The photo of the Yankee Flyer Diner looks to be from the early 1940s, as the diner had a site-built entryway, which did not come with the building when it left the J.B. Judkins Company in 1939. This diner was the first streamliner model out of the Judkins factory, and it was bought to replace a 1930 vintage Worcester Lunch Car that was previously on the site. In Nashua the memory of this diner is still very strong even though it has been gone since the 1960s, I believe. Back in the 1990s, a mural was painted on a blank wall that faced a municipal parking lot in downtown Nashua depicting the local landmark, ironically not far from where it operated.

POSTCARD, ELLA MAY DINER, LINCOLN, NEW HAMPSHIRE

The Ella May Diner, once located in Lincoln, is the only known example I have found to date of a converted trolley car in the Granite State. I am sure there were more because, at one time after the turn of the century

128

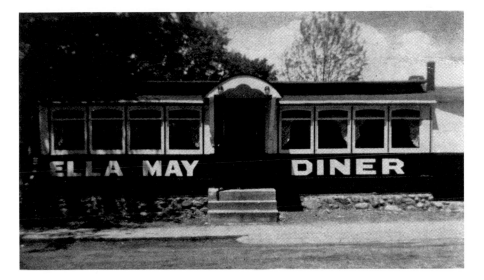

A postcard of the Ella May Diner, once located in Lincoln, New Hampshire. This was an example of a trolley car-to-diner conversion. *Collection of the author.*

(early 1900s), there were many examples of retired trolleys and railroad cars turned into diners. It was an inexpensive way for someone to get into the diner business, although this type of place did give diners a bad reputation. These conversions also helped to perpetuate the myth that all diners were former railroad cars or trolleys.

POSTCARD, EVERETT'S DINER, GROVETON, NEW HAMPSHIRE

Everett's Diner was located in Groveton, described on Wikipedia as a "census designated place" in the town of Northumberland. This is just north of Lancaster in Coos County, New Hampshire. The manufacturer of this diner is unknown and is very hard to identify, mostly because the roofline is covered by signage. My educated guess is that part of the structure is factory-built while the rest is an on-site addition. It is no longer extant.

A postcard of Everett's Diner located on U.S. Route 3 in the Groveton section of Northumberland, way up in Coos County. I am not sure of the manufacturer, but it does look to be factory built. *Collection of the author.*

A postcard of the Red Arrow Diner of Nashua, New Hampshire. This was thought to be part of the chain of Red Arrow Diners back in the 1930s. *Collection of the author.*

POSTCARD, RED ARROW DINER, NASHUA, NEW HAMPSHIRE

Believed to once be a part of the southern New Hampshire chain of Red Arrow Diners, this diner went on to be known as Rochette's Diner. It was located at 223½ Main Street in Nashua. This diner was one of at least two known Brill diners in Nashua. The other one was the Miss Nashua Diner, which was located up the street where Collins Flowers is today, across from the Hunt Memorial Building. Both were more than likely built by Wason Manufacturing Company out of Springfield, Massachusetts. Wason was the Diner Division of the J.G. Brill Company of Philadelphia, Pennsylvania.

POSTCARD, SHORE DINER, LACONIA, NEW HAMPSHIRE

The Shore Diner was a very popular place in the Lakeport neighborhood of Laconia. The left side is the original diner while the right is an addition for more seating. It was replaced eventually by a Burger King franchise, which itself has since closed.

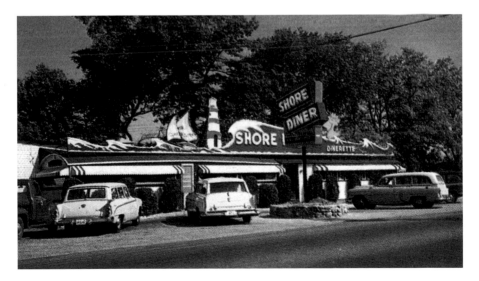

This image of Jerry's Shore Diner was used for postcards or, as in this case, a business card. The diner was located on U.S. Route 3 in the Lakeport section of Laconia. *Collection of the author.*

APPENDIX I

Spider Osgood

New Hampshire's Legendary Short-Order Cook

Since 1980, when I started this diner odyssey, I count myself among the privileged to have witnessed some old-time "grill men" who were extremely adept at manning the grill and working a back bar efficiently and quickly. This usually took place in the older diners that still had the cooking area right behind the counter. I have become friends over the years with a few of these guys. Even now there are still some good ones, such as Jose Ramirez of Buddy's Diner in Somerville, Massachusetts, who, while relatively young, can really handle the action in any situation. A couple of guys from the past who really stand out in my mind are Buddy Fennell at the Capitol Diner and Ron Goodman at the old Red Rambler Diner, both in Massachusetts as well. But I recall hearing or reading about some short-order cooks who could put on a show and basically entertain you while you were waiting for your food. Around 1985, I started hearing of an almost mythical "grill man" that plied his trade in New Hampshire. At that time, I had started putting on slide lectures for various organizations. The first one was for the Medford (Massachusetts) Historical Society in November of that year. When I was setting up the projector and making sure everything was ready for that first presentation, a gentleman came up to me and started talking about diners. He introduced himself as George Surabian. I knew of him and may have met him years earlier as his parents had been friends with my parents going back decades. In fact, his mother and my mother grew up in the same neighborhood. George was almost twenty years my senior, but we hit it off immediately. It turns out that George was a bit of a diner

A photo of Spider Osgood behind the counter at the Paugus Diner (now the Union Diner). *Circa 1991 photo by George Surabian, from the collection of the author.*

aficionado himself and from memory could name places in and around the area that no longer existed. We remained extremely friendly right up until his sudden passing away in 1994 at the age of sixty. In fact, as I was in the process of writing this, I checked and realized ironically that the twentieth anniversary of his passing was within a day or two.

The reason that I mention George is that he was the first person to tell me about this short-order cook in New Hampshire who was known by the nickname of Spider. You see, George, along with various members of his family, had maintained vacation property in the Lakes Region of New Hampshire for many years, and he was familiar with the local diners in that area. This is how he knew about Spider. The stories George told me about Spider were almost unbelievable. Spider's total command of the diner's back bar as well as his prowess working the grill were legendary. As George went on to tell me, it was almost exhausting to watch Spider work, his quickness in getting the meals pushed out to the waiting customers was beyond anything

most people (including myself) have ever experienced. What, to him, was just his natural movement was, to the captive audience (his customers), pretty much a form of performance art. In fact in 1989, I was being interviewed for a segment on diners for Charles Kuralt's CBS *Sunday Morning* television show. We were at the aforementioned Capitol Diner in Lynn, Massachusetts, for the interview, and the camera operator related to me that he had gone to college in New Hampshire during the early 1970s and recalled seeing this unbelievable short-order cook called Spider. I told him I had heard of Spider and his reputation was known far and wide.

So in researching the Union Diner of Laconia recently for this book, I brought up Spider's name to Kathleen Blackey Clark, whose parents ran that very same diner as the Paugus Diner from the late 1970s to the early 1980s. She mentioned that Spider had passed away fairly recently. I started thinking about him and decided to see what was out there on the Internet about him. Boy was I surprised by what I found. First of all, his obituary was available, which gave me some good background on him. The second piece to the puzzle I found in my Internet search pretty much solidified all the stories I have heard about Spider over the years. I found that someone actually took the time to film him in action when he was in prime form. This movie, which was filmed in 1971 by Gary Anderson of newhampshiremovies.com, is now a video on YouTube. The movie was entirely of Spider manning the grill one night at Paul's Diner (now the Union Diner). In my opinion, this movie goes a long way to help make up for the fact that I never got to see this guy in action. The following is a short biography about Spider from what I have learned.

Kenneth S. "Spider" Osgood was a lifelong resident of Laconia, New Hampshire, who may have been short in stature but huge in personality. He was an amateur boxer in his youth and very quick on his feet. When he was a teenager in the 1940s, he started working as a short-order cook in local restaurants, including the Shore Diner and later Paul's Diner, both in the Lakeport area of Laconia. He was noted for his multitasking ability working the grill, usually on the night shift. He received the nickname Spider early on in his career when a co-worker made note of his quick movements behind the counter, especially his arm motions and short stature. The co-worker said Osgood reminded him of a spider, and the name stuck.

Over the years Spider did other things besides working at diners. As mentioned above, he did a stint as a golden glove amateur boxer in his youth and also operated a longtime family business doing antique clock repairs. He was employed as a lathe operator at Baron Machine Company as well as

the Scott and Williams Company, manufacturers of knitting machines, both located in Laconia. He was also employed at various times at King's Grant Inn of Gilford, New Hampshire, and Karl's Restaurant in the Weirs Beach section of Laconia. Spider made a brief appearance manning the grill of the Paugus Diner in the early 1990s, and my friend George Surabian managed to snap a few photos of him. These photos have been a part of my collection for years. Sadly, Spider passed away on January 17, 2012. I do not believe we will ever see the likes of him again. He was pretty much one of a kind.

APPENDIX II

List of Diners in New Hampshire

Here is a list of diners known to currently exist in New Hampshire today. It is by no means complete and is certainly subject to change. I have separated the list into two appendices. The first, Appendix II, consists of all the diners featured in Chapters 1 through 4. Appendix III notes three places that are former diners being repurposed. The rest of Appendix III features a whole group of local restaurants that serve their respective communities breakfast, lunch and, sometimes, dinner.

AIRPORT DINER
2280 Brown Avenue, Manchester
Built on site

BRISTOL DINER
33 South Main Street, Bristol
1926 or '27 Pollard Diner

DADDYPOP'S TUMBLE INN DINER
1 Main Street, Claremont
1941 Worcester Lunch Car (No.778)

FOUR ACES DINER
23 Bridge Street, Lebanon
1952 Worcester Lunch Car (No.837)

GEORGE'S DINER
10 Plymouth Street, Meredith
Built on site

GILLEY'S P.M. LUNCH CART
175 Fleet Street, Portsmouth
1939 Worcester Lunch Car (No. 744)

HILLSBOROUGH DINER
89 Henniker Street, Hillsborough
1953 Kullman Diner

HOMETOWN DINER
Route's 119 and 202, Rindge
1949 Silk City Diner (No. 4931)

HOPE'S HOLLYWOOD DINER
1277 Plaistow Road (Route 125), Plaistow
1952 Mountain View Diner

JOANNE'S KITCHEN AND COFFEE SHOP
219 Main Street, Nashua
1920s Worcester Lunch Car

JOEY'S DINER
1 Craftsman Lane and Route 101A, Amherst
Built on site

LINDY'S DINER
19 Gilbo Street, Keene
1961 Paramount Diner

LIONS CORNER POPCORN WAGON
Mast Road and High Street, Goffstown
Homemade 1930s popcorn wagon

LITTLETON DINER
145 West Main Street, Littleton
1940 Sterling Diner

MAIN STREET STATION DINER
105 Main Street, Plymouth
1946 Worcester Lunch Car (No. 793)

MARY ANN'S DINER-RESTAURANT
29 East Broadway, Derry
Built on site

MISS WAKEFIELD DINER
7 Windy Hollow Road, Wakefield
1949 Jerry O'Mahony Diner

MT. PISGAH DINER
118 Main Street, Winchester
1941 Worcester Lunch Car (No. 769)

PETERBORO DINER
10 Depot Street, Peterborough
1950 Worcester Lunch Car (No. 827)

PLAIN JANE'S DINER
897 Old Route 25, Rumney
1954 Jerry O'Mahony Diner

RED ARROW DINER-MANCHESTER
61 Lowell Street, Manchester
Built on site

RED ARROW DINER-MILFORD
63 Union Square, Milford
1920s Liberty Diner

RED BARN DINER
113 Elm Street, Manchester
1920s Worcester Lunch Car

RILEY BROS. DINER
1381 Village Road, Madison
1941 Sterling Diner

ROGER'S RED LINER DINER
2454 Lafayette Road (U.S. Route 1), Portsmouth
1950 Jerry O'Mahony Diner (No. 2163-50)

ROUTE 104 DINER
752 New Hampshire Route 104, New Hampton
1957 Worcester Lunch Car (No. 850)

SUNNY DAY DINER
Route 3, Lincoln
1958 Master Diner

TILT'N DINER
61 Laconia Road, Tilton
1950 Jerry O'Mahony Diner (No. 2179-50)

UNION DINER
1331 Union Avenue, Laconia
1951 Worcester Lunch Car (No.831)

List of "Former" Diners and Other On-Site Diner-Type Restaurants in New Hampshire

As noted above, this third appendix mentions three places that are former diners being repurposed (noted with an [*]) as well as a whole group of local restaurants that serve their respective communities breakfast, lunch and, sometimes, dinner.

ALICIA'S DINER
116 Bridge Street, Pelham
Built on site

ANDRE'S DINER
100 Willow Street, Manchester
Built on site

BETTY'S KITCHEN
164 Lafayette Road, North Hampton
Built on site

CASEY'S DINER
13 Plaistow Road, Plaistow
Built on site

CENTER HARBOR DINER
17 Whittier Highway, Center Harbor
Built on site

COTE'S DINER
8 Pinard Street, Goffstown
Built on site

DERRY DINER
29 Crystal Avenue, Derry
Built on site

EASTERN DEPOT RESTAURANT
6 Unity Street, Berlin
Built on site

EGGIE'S FAMILY RESTAURANT
6 Main Street, Atkinson
Built on site

FAST EDDIE'S DINER
320 Lafayette Road (U.S. Route 1), Hampton
A former Pizza Hut

GILLY'S BREAKFAST AND LUNCH
322 Lake Street, Bristol
Built on site

GREG'S PLACE
641 Elm Street, Manchester
Built on site

HAPPY CORNER CAFÉ
Route 3, Pittsburg
Built on site

HOWARD'S RESTAURANT
143 Main Street, Colebrook
Built on site

LACORONA MEXICAN RESTAURANT*
83 Farmington Road, Rochester
2001 Starlite Diner

L-B TAILORING*
18 South Main Street, Concord
A former diner, more than likely a Worcester Lunch Car

LIVE FREE OR DINER
5 Plaistow Road, Plaistow
Built on site

MANCHESTER DINER
119 Hanover Street, Manchester
Built on site

MARGIE'S DREAM DINER
172 Hayward Street, Manchester
Built on site

MARY ANN'S DINER-RESTAURANT
4 Cobbetts Pond Road, Windham
Built on site

MURPHY'S DINER
516 Elm Street, Manchester
Built on site

NANCY'S DINER
25 Canal Street, Nashua
Built on site/former Valentine Diner

NORTON'S CLASSIC CAFÉ
233 Main Street, Nashua
Built on site

OUR PLACE RESTAURANT
981 Union Avenue, Laconia
Built on site

PINK CADILLAC DINER
17 Farmington Rd, Rochester
Built on site

POOR BOY'S DINER
136 Rockingham Road, Londonderry
Built on site

POOR PIERRE'S
303 Main Street, Nashua
Built on site

RONNIE'S COUNTRY KITCHEN
200 Temple Street, Nashua
Built on site

ROUNDABOUT DINER
580 U.S. Route 1 Bypass, Portsmouth
A former Howard Johnsons

SUMMER PUB*
122 Main Street, Charlestown
1930s Worcester Lunch Car

SUZIE'S DINER
76 Lowell Street, Hudson
Built on site

SWANZEY DINER
515 Monadnock Highway, Swanzey
Built on site

TRACKSIDE CAFÉ
66 Lincoln Street, Exeter
Built on site

APPENDIX IV

List of Diner Manufacturers

Similar to classic automobile enthusiasts who are adept at knowing many automobiles by make, model and year of manufacture, so, too, do diner aficionados pride themselves on being able to identify which diner manufacturer built any one particular diner and possibly the year in which it was built, etc. For example, to the untrained eye, one stainless steel diner looks pretty similar to another. In fact, I actually did a slide presentation a number of years ago that I titled "Is it a Fodero or an O'Mahony?" Through this presentation I attempted to show the similarities as well as the differences between not just those two diner builders but any manufacturer. I pointed out some of the design features that set one builder apart from another and the differences in style and workmanship that someone with an experienced eye can usually spot to help in the process of identification.

Ironically, in trying to identify who built a diner, some of these details could sometimes get confusing. As an example, say one particular diner built by Mountain View Diners had been traded in to Kullman Diners. Kullman would have turned around and sold that diner as a reconditioned unit, but before doing so, it would have completely changed the exterior while possibly keeping the interior fairly intact. So now the diner aficionado comes along and sees a Kullman diner on the outside and a Mountain View diner on the inside.

Massachusetts can be credited with the birth of the diner building industry going back to the late 1800s with people like Sam Jones, Charles Palmer and Thomas Buckley leading the way with the burgeoning lunch wagon business. Historically, there have been more than sixty manufacturing concerns that

were in the business of building or renovating diners over the years since 1872. Some of these started out building lunch wagons and evolved into constructing larger diners. Similar to neighboring Massachusetts, New Hampshire was long represented by the likes of the Worcester Lunch Car Company in Worcester and J.B. Judkins Company, the manufacturers of Sterling diners out of Merrimac, Massachusetts. There were many more companies from New York and New Jersey that built diners and quite a few of these diners were delivered and installed in New Hampshire. All the initial information on these companies is credited to the research of Richard J.S. Gutman.

The following is a list of manufacturers that have examples of their product still extant in New Hampshire.

WORCESTER LUNCH CAR COMPANY
4 QUINSIGAMOND AVENUE, WORCESTER, MASSACHUSETTS

This was the premier diner manufacturer in New England, operating from 1906 until the assets of the company were sold at auction on May 24, 1961. The company built 651 units (lunch wagons to diners). It was a direct descendant of the T.H. Buckley Lunch Wagon and Catering Company as well as the Haynes and Barriere Company. Worcester was noted for its fine workmanship and detail with interiors featuring oak, gumwood and mahogany woodwork, as well as ceramic tile walls and counter apron. The company was also known for its exteriors, which sported porcelain-covered steel panels with integral graphics baked into them. Many diners found in northern New England were built by this company. Some prime examples are the Union Diner, Four Aces Diner and Daddypop's Tumble Inn Diner.

J.B. JUDKINS COMPANY (STERLING DINERS)
18 MAIN STREET IN MERRIMAC, MASSACHUSETTS

J.B. Judkins was a wagon builder for many years (starting in 1857) and was famous for its line of fancy wagons, landaulets and later luxury automobile bodies. It switched to building Sterling diners in 1936. A handful of the

first Sterling diners featured a monitor roof with clerestory vent windows. After those first few diners, the company modified the roof style slightly, and the style was sort of a cross between a barrel roof and a monitor roof. By 1940, Judkins had introduced a fully streamlined model with a bullet nose on one or both ends. This Sterling Streamliner proved to be very popular, but the company had closed shop by 1942. New Hampshire was home to three Sterling Streamliners over the years: the Yankee Flyer, Rainbow Vets and Ralph's Place. There are currently two non-streamlined Sterling diners in the Granite State: the Littleton Diner and Riley Bros. Diner.

KULLMAN INDUSTRIES, INC.
ONE KULLMAN CORPORATE CENTER DRIVE, LEBANON, NEW JERSEY

Kullman Industries was founded in 1927 by Samuel Kullman, who had been an accountant with P.J. Tierney Sons Diners. First known as Kullman Dining Car Company, the business became a leader in the industry and was building diners well into the 2000s. After bankruptcy, with corporate restructuring and new ownership in recent years, the company focused on what it termed "offsite" construction, building all types of modular structures from schools, prisons and other noncommercial applications and basically dropped diners from its product line. Unfortunately, Kullman went out of business in December 2011. The Hillsborough Diner in Hillsborough is the only operating example from this company in the state.

MOUNTAIN VIEW DINERS
ROUTE 23, NO. 20 NEWARK-POMPTON TURNPIKE, SINGAC, NEW JERSEY

This company had a stylish, well-built product. The company operated from 1939 until it shut production down in 1957. Hope's Hollywood Diner in Plaistow is the Granite State's only representative of a vintage (though altered) Mountain View Diner.

PATERSON VEHICLE COMPANY
(SILK CITY DINERS)
EAST TWENTY-SEVENTH STREET AND NINETEENTH AVENUE, PATERSON, NEW JERSEY

This company started building Silk City Diners in 1927. Its first diners were barrel-roofed models similar to what Jerry O'Mahony, P.J. Tierney Sons and Worcester Lunch Car were producing at that time. Silk City Diners were usually never custom built; they only offered a stock model that could vary in size and color only. The company closed in 1964. To my knowledge, there were only two Silk City Diners ever in the state of New Hampshire. One came here earlier in the 2000s but is actually in private hands and not open to the public. Known as Betsy and Mike's Diner, the owners have it on their property in Exeter and use it for parties, etc. The second one was delivered in 2013. That would be the Hometown Diner in Rindge. Coincidently, both diners were completely rehabbed by Steve Harwin's Diversified Diners of Cleveland, Ohio.

JERRY O'MAHONY, INC.
977-991 WEST GRAND STREET, ELIZABETH, NEW JERSEY

This company was one of the more famous diner builders out of the Garden State. Started in 1913, O'Mahony and his partner John J. Hanf built diners out of a small garage in Bayonne. Because of the quality of construction, the popularity of this company allowed it to become steadily larger over the years, outgrowing the manufacturing facilities four times, ending up at the address in Elizabeth. The company, whose slogan was "In Our Line We Lead the World," built their last diner in 1956. New Hampshire currently has quite a few 1950s O'Mahony diners operating, including, Plain Jane's, Miss Wakefield, Tilt'n and Roger's Redliner.

STARLITE DINERS, INC.
323 SECOND STREET, HOLLY HILL, FLORIDA

Starlite Diners was started in 1992 by Bill and Donna Starcevic. Starlite initially offered three sizes of diners: a 52 seater, another slightly larger seating 82 and still another seating 102. At some point, the Starcevics named

the company Valiant Diners. Valiant built its last diner in 2004. In September 2005, Don Memberg, owner of a company called Modular Diners, Inc., of Atlanta, Georgia, obtained the rights to build Starlite Diners. The only Starlite diner in New Hampshire is the former Remember When Diner of Rochester, now being used as LaCorona Mexican Restaurant.

MASTER DINERS
NEWARK-POMPTON TURNPIKE, PEQUANNOCK, NEW JERSEY

The company started building diners in 1947 and only lasted into the mid-1950s. It built a few different styles that were kind of unique but still had a classic stainless steel look that everyone associates with a 1950s diner. Master Diners never made a lot of inroads in the New England. In fact Connecticut, Rhode Island, Massachusetts and New Hampshire each had a new Master diner delivered during the 1950s. The Sunny Day Diner in Lincoln (originally Stoney's Diner in Dover, New Hampshire) is the only Master Diner currently operating in New Hampshire.

PARAMOUNT MODULAR CONCEPTS
56 SPRUCE STREET, OAKLAND, NEW JERSEY

Paramount Diners were originally built in Haledon, New Jersey, starting in 1932 by Arthur E. Sieber, who had learned the trade working for Silk City Diners. Among the many innovations Paramount is credited with is the development of its patented "split construction" method, the precursor to all modular construction widely used to this day in the diner industry. Another innovation was its extensive early use of stainless steel for the interior and exterior construction of diners. Since 1963, the company was under the ownership of Herbert Y. Enyart, another former employee of Silk City Diners. Lindy's Diner in Keene is the only Paramount Diner known to be delivered to New Hampshire.

LIBERTY DINING CAR COMPANY
CLARENCE, NEW YORK

This company was owned by C.A. Ward, a former partner in the Ward & Dickinson Company, the largest and most prolific builder of diners in the Lake Erie region of New York. The company's probable years of operation were 1928 to 1931. C.A. Ward was in the hospital at the end of 1927, and he had already sold his share of the company to Mr. Lee Dickinson. The company had offices in Buffalo, where at least two of its diners were located. The Milford Red Arrow Diner is reportedly a product of this company.

THE POLLARD COMPANY, INC.
LOWELL, MASSACHUSETTS

Owned by Wilson H. Pollard, who had previously operated a lunch wagon in Lowell, the company joined forces with a sheet metal worker by the name of Joseph E. Carroll. The Pollard Company reportedly built a small amount of diners of which two actually survive to this day. These two survivors are the Palace Diner in Biddeford, Maine, and the Bristol Diner in Bristol, New Hampshire.

Index

About the Author

Larry Cultrera is an archivist/photographer of the American roadside, specializing in documenting the American diner through his photographs. He is a longtime member of the Society for Commercial Archeology (SCA). Since October 2007, Cultrera has authored the Diner Hotline weblog (http://dinerhotline. wordpress.com), which is a continuation of a column he penned for the SCA's *Journal Magazine* for over eighteen years. He has been researching diners and their history since 1980, although he can trace his interest back to his childhood in Medford, Massachusetts. He has photographed and kept a running log (now a computerized database) of over 830 of these truly unique American restaurants and has a collection of memorabilia consisting of everything from postcards, menus, matchbook covers and business cards to toy diner models, T-shirts and actual selected pieces of now demolished diners, such as marble countertops, exterior panels, signs and light fixtures.

Mr. Cultrera has been featured on various TV shows that covered the subject of diners, such as CBS *Sunday Morning* with Charles Kuralt, Bob Elliot presents *New England Diners* (WCSH channel 6, Portland, Maine) which also ran on cable TV's Discovery Channel. He has also appeared on WCVB TV's

Chronicle. He has been interviewed for numerous newspaper and magazine articles ranging from the *Boston Globe*, the *Syracuse (NY) Post Standard* and the *Portland (ME) Press Herald* to *Smithsonian Magazine*, *Insight Magazine* and *Yankee Magazine*. Mr. Cultrera has authored a previous book entitled *Classic Diners of Massachusetts* for The History Press. He also conducts popular presentation/ lectures on subjects related to the American roadside for various historical societies, art associations and other interested organizations.